*The Campus History Series*

# ST. LAWRENCE
# UNIVERSITY

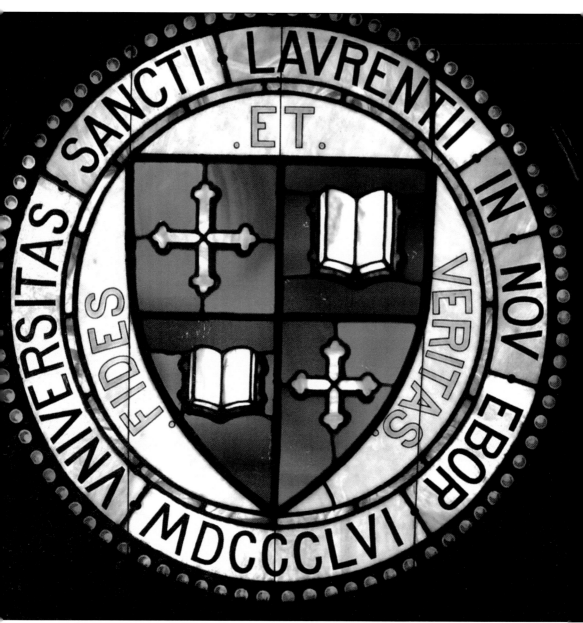

This representation of the seal of the university is part of the stained glass window in Herring-Cole Hall.

*The Campus History Series*

# ST. LAWRENCE UNIVERSITY

David E. Hornung and Peter E. Van de Water

ARCADIA
PUBLISHING

Copyright © 2005 by David E. Hornung and Peter E. Van de Water
ISBN 978-0-7385-3934-8

Published by Arcadia Publishing
Charleston, South Carolina

Printed in the United States of America

Library of Congress Catalog Card Number: 2005932040

For all general information, please contact Arcadia Publishing:
Telephone 843-853-2070
Fax 843-853-0044
E-mail sales@arcadiapublishing.com
For customer service and orders:
Toll-Free 1-888-313-2665

Visit us on the Internet at www.arcadiapublishing.com

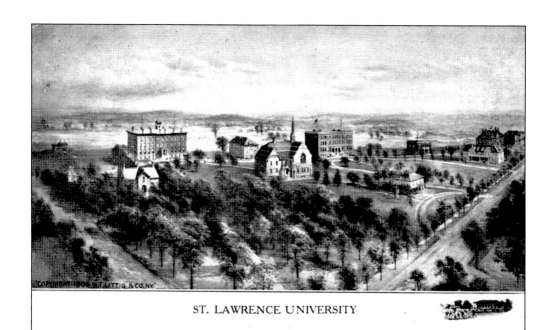

ST. LAWRENCE UNIVERSITY

This postcard shows the campus as it appeared in the early 1900s.

# CONTENTS

# ACKNOWLEDGMENTS

The postcards reproduced here were from a private collection. The originals for all other images are located in the Special Collections and University Archives of the Owen D. Young Library. We acknowledge the assistance of the staff of the archives in locating and screening the images. In particular, we acknowledge Darlene Leonard's help in locating certain images and in meeting our numerous requests cheerfully and expeditiously. We also acknowledge the efforts of Emily Flack, student intern, who did much of the scanning of the images from the University Archives. A faculty research grant awarded to author David E. Hornung by Liz Regosin, associate dean for academic affairs, funded the scanning charge imposed by the library.

For assistance in the early stages of the production of this book, we acknowledge the enthusiastic support of St. Lawrence University colleagues Lisa Cania, associate vice-president for University Communications, and Robert Fitzrandolph, manager of the University Bookstore. We are also indebted to Neil Burdick, director of University Publications, for his careful reading of our final draft. His discerning eye for language and facts is much appreciated. Some of the text in this book is reproduced, with permission, from the university Web site, www.stlawu.edu. Discussions with Dotty Hall were invaluable in helping us understand the history of women's athletics at the university. We owe a special thank-you to our spouses—Susan Ward, professor of English, and Becky Van de Water '60—for their encouragement. Errors of content and omission are solely the responsibility of the authors.

# INTRODUCTION

Founded on April 3, 1856, St. Lawrence University is the oldest continuously coeducational institution of higher learning in New York State. It is located in Canton, a village of 7,000, where the Adirondack foothills rise from the St. Lawrence River Valley. The university was chartered as both a Universalist theological school and a college of letters and science. The Universalist Church, one of the more liberal of the Protestant sects, championed ideas such as critical thinking and gender equality. These attributes surfaced in the new university, which from its beginning was progressive in its educational philosophy. Since the closing of the Seminary Division in 1965, the university has had no formal ties with any religious denomination.

The Theological School began to accept students immediately after the founding in 1856 but, initially, the faculty of the College of Letters and Science found it necessary to create a Preparatory Division to bring prospective students to the level required for entry to a demanding four-year liberal arts curriculum. From struggling beginnings, the university has evolved to today's liberal arts institution with an enrollment of approximately 2,000 undergraduate students and a regional and national reputation.

The current mission of St. Lawrence University is "to provide an inspiring and demanding undergraduate education in the liberal arts to students selected for their seriousness of purpose and intellectual promise." The university offers a four-year undergraduate program of study in the liberal arts and graduate programs in education. The university awards bachelor of arts, bachelor of science, and master of education degrees and a certificate of advanced studies in educational administration. Movie stars, sports legends, government officials, a law school, Madame Curie, and the SS *St. Lawrence Victory* are all part of the rich history of St. Lawrence University.

Although the university of the 19th century was austere, it still provided an opportunity for nonacademic activities. As the century drew to a close, sports teams—notably men's basketball and track—were fielded, a student government was formed, and organizations for music, drama, social activism, and the literary arts began to draw attention. At this time, the first Greek-letter organizations, today's fraternities and sororities, also took root.

Following a difficult period during the Great Depression and World War II, the student body increased quickly, as did the physical plant. A four-building campus serving some 300 students in the early 1940s became a 30-building campus serving 2,000 students within 25 years.

Among St. Lawrence's 24,000 alumni are communications magnate and diplomat Owen D. Young, for whom the Young Plan for European War Reparations was named; Olympia Brown, the first woman in U.S. history to be ordained a minister; authors Irving Bacheller and Lorrie Moore; U.S. Sen. Susan Collins of Maine; and actor Kirk Douglas.

In a few instances, we have mentioned people and places that are part of the present university, but this volume covers mostly people, structures, and events from the founding of the university to the 1970s. We recognized that it was not possible to cover all the important academic, social, and athletic accomplishments that could have been mentioned. We were constrained by a space limitation, availability of photographs, and our own incomplete understanding of all the events that have shaped St. Lawrence. Nevertheless, we hope readers will get some appreciation of the history of the university from what we report. The ideals of the founders of the university have survived and will continue to survive as a result of the day-to-day successes of the people passionately involved with this institution of higher education.

# *One*

# THE CAMPUS

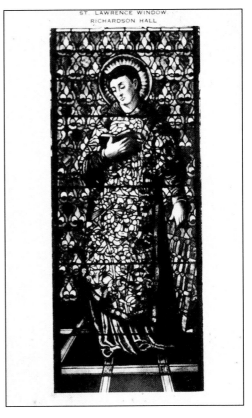

According to tradition, St. Lawrence, the saint, distributed the treasures of the church to the poor. He was martyred on a gridiron of live coals. With his last breath, he called to his tormentors, "Now turn me, this side is quite done." The river flowing northeast from the Great Lakes was named the St. Lawrence by French explorer Jacques Cartier because, in 1535, he sailed into its estuary on Saint Lawrence's feast day. St. Lawrence County took its name from the river, and St. Lawrence University took its name from the county.

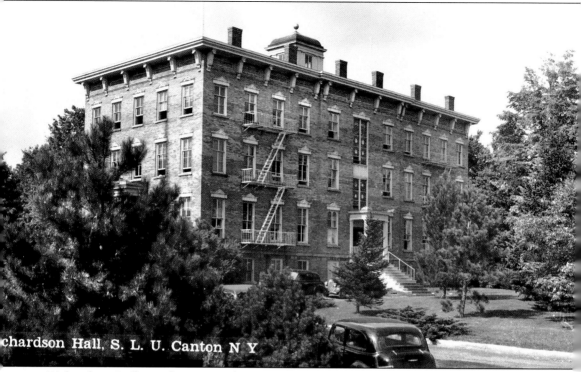

chardson Hall, S. L. U. Canton N Y

Richardson Hall, on the National Register of Historic Places, was built as College Hall in 1856. In the early years, it was the only college building. Men and women students ate there, slept there, and took classes there. From the beginning, St. Lawrence was coeducational, and it remains the oldest continuously coeducational college in New York State. One of the first male students wrote, "We have some fine-looking girls and some that are not so fine." Richardson's fire escapes and the oiled, grooved wooden stairs worn thin by generations of students were removed in a 1962–1963 renovation.

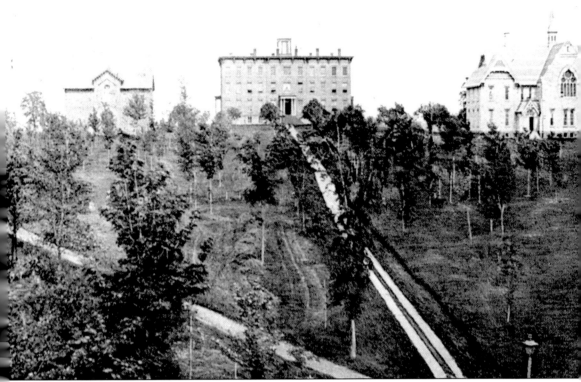

This is the Hill as viewed from Park Street. Herring Library is on the left, Richardson Hall (then called College Hall) is in the middle, and Fisher Hall, home of the Theological School, is on the right. The trees were planted during Tree Holidays, a tradition begun in 1869. Classes were canceled and students and faculty transplanted trees from the surrounding woods to the library slope. In 1910, after the Tree Holidays had deteriorated into free-for-all fights between freshmen and sophomore men, the tradition was discontinued.

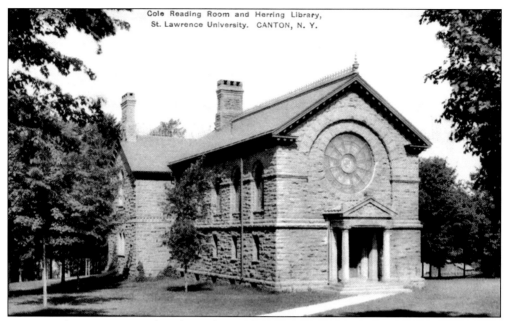

Cole Reading Room and Herring Library, St. Lawrence University. CANTON, N. Y.

Herring Library was joined to the Cole Reading Room in 1903. At its beginning, Herring Library had no provisions for artificial lighting, so it could not be used after dark. Now on the National Register of Historic Places, Herring-Cole Library housed the university's collections until Owen D. Young Library was built in 1959.

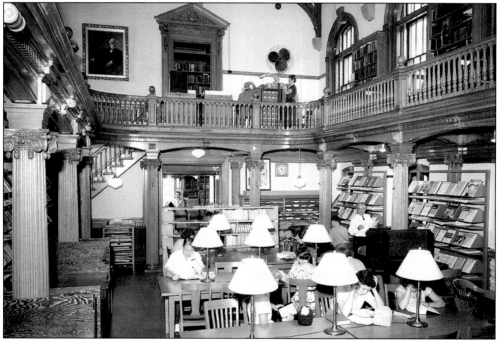

Pictured here is the interior of Herring-Cole Library. In the right background is longtime librarian Andy Peters. Students of the 1950s recall standing in line before 7:00 p.m. to get a study seat when Herring-Cole opened for evening hours. Students called the dark, dank study area in the basement "the Catacombs."

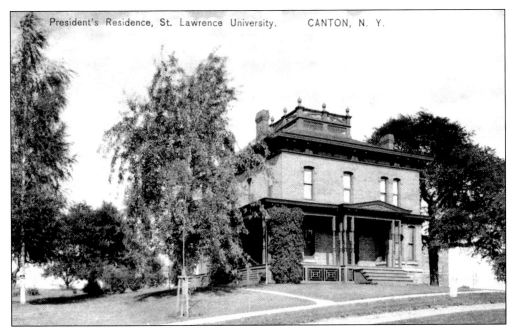

This 1887 building was the home of St. Lawrence's presidents. It served as Park Street Hall, the campus administrative building, until the administration moved to Vilas Hall in 1965. Park Street Hall was razed to make space for the Owen D. Young Library.

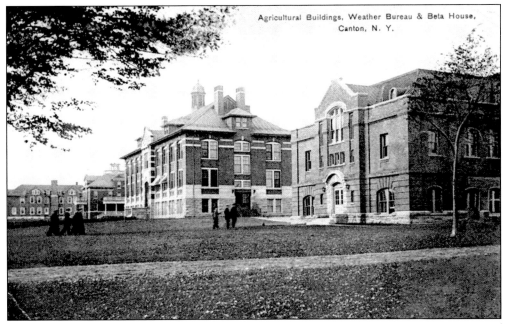

On July 1, 1907, the New York State Legislature provided $80,000 for the construction of a state school of agriculture at St. Lawrence University. A total of 13 students graduated from this school in 1909. In 1949, the school became a unit of the State University of New York.

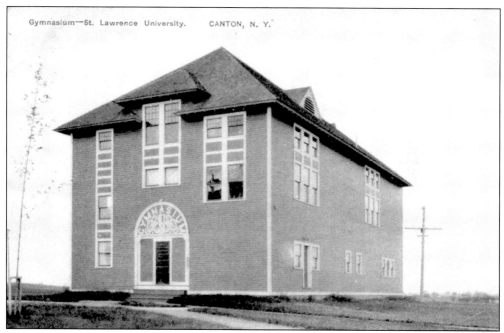

Gymnasium—St. Lawrence University.    CANTON, N. Y.

This early-1900 postcard is of the "Old Gym," built of wood for $3,000. At the dedication in 1876, Mrs. Bryant of Potsdam sang an aria from *Romeo and Juliet*. Electric lights were not added until 1901.

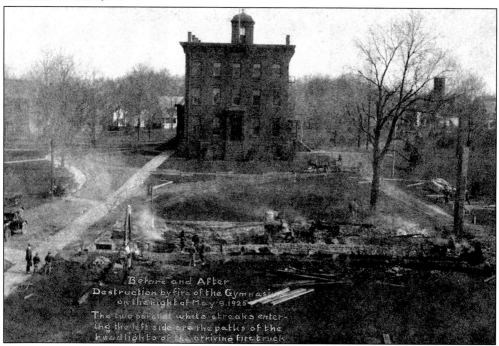

Before and After
Destruction by fire of the Gymnasium
on the night of May 9, 1925
The two parallel white streaks enter-
ing the left side are the paths of the
headlights of the arriving fire truck

In 1925, the Old Gym went down in flames, but Richardson Hall still stood. The fire was of unknown origin, but St. Lawrence legend contends that the shabby old bandbox was burned by students hoping for a better facility. The Old Gym was located where Gunnison Chapel now stands.

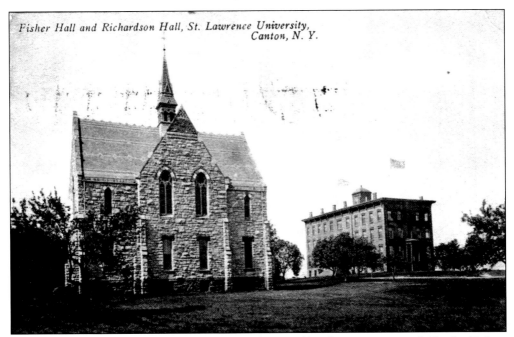

*Fisher Hall and Richardson Hall, St. Lawrence University, Canton, N.Y.*

This 1912 postcard shows Fisher and Richardson Halls. This view inspired Charles Kelsey Gaines 1876 to write: "Lo! The summit of a hill in a far off northern land, a sturdy old pile doth crown. From the summit of that pile—may its walls forever stand—wave the folds of the scarlet and the brown."—From "The Scarlet and the Brown," a traditional St. Lawrence song.

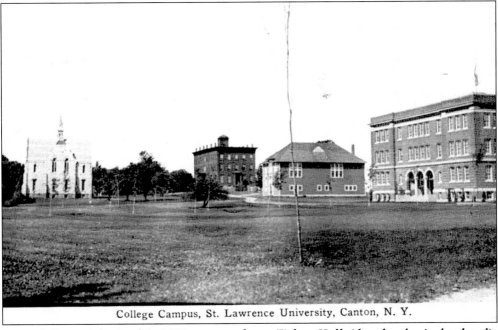

College Campus, St. Lawrence University, Canton, N. Y.

From left to right in this 1911 postcard are Fisher Hall (the theological school), Richardson Hall, the gymnasium, and Carnegie Hall. This quadrangle is now used for university commencements.

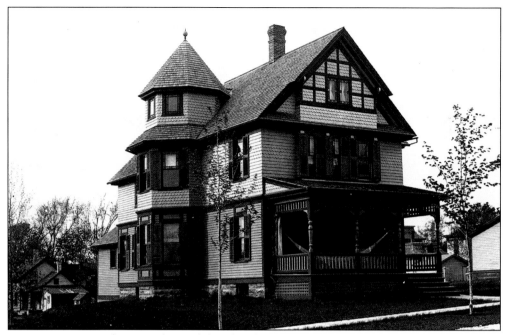

Henry Prentiss Forbes was dean of the Theological School, and his home, pictured here, stood on University Avenue. He and his wife, Harriet Elizabeth, were gracious hosts; their home was the social center for theological students. Forbes was a lifelong crusader against liquor, and it is reported that he and Prof. Henry Priest raided one of Canton's illegal gin mills. Forbes's house is now home to some of the English Department offices.

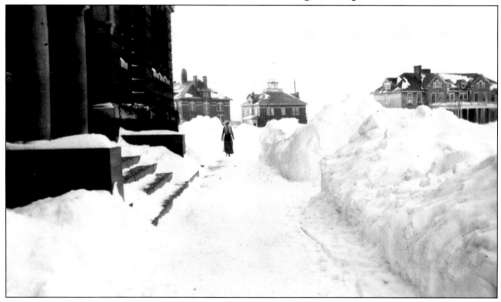

This early-20th-century postcard shows Carnegie Hall on the left, and in the background, from left to right, Cook Hall (now Piskor [pronounced "peace corps"] Hall), the weather station (now Memorial Hall), and the Beta Theta Pi house (where Sykes Residence is now located). Graduates of the 1930s, 1940s, and 1950s recall severe winters that get harsher with each retelling.

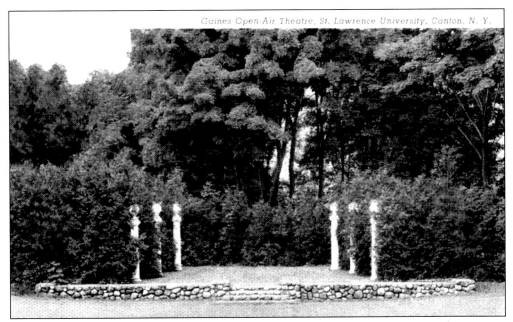

Gaines Open Air Greek Theater was on the slope where Owen D. Young Library now stands. It was named for Cammie Woods Gaines 1876, wife of Charles Kelsey Gaines 1876, professor of Greek and author of *Gorgo, A Romance of Old Athena* (1903). The theater was used for concerts and plays.

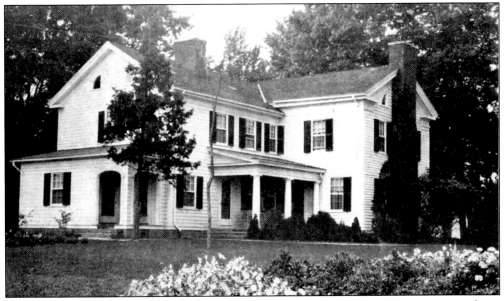

Richard Eddy Sykes 1883 was a Canton boy who was president of St. Lawrence from 1919 to 1935. He and Owen D. Young, chairman of the St. Lawrence Board of Trustees, initiated an era of expansion that included Young's donation of the Harison farm and house (1818) as the St. Lawrence president's home. Richard Harison was a classmate of John Jay, a law partner of Alexander Hamilton, and a close friend of George Washington. The house is now called the MacAllaster House, thanks to recent renovations made possible by the MacAllaster and Torrey families.

17

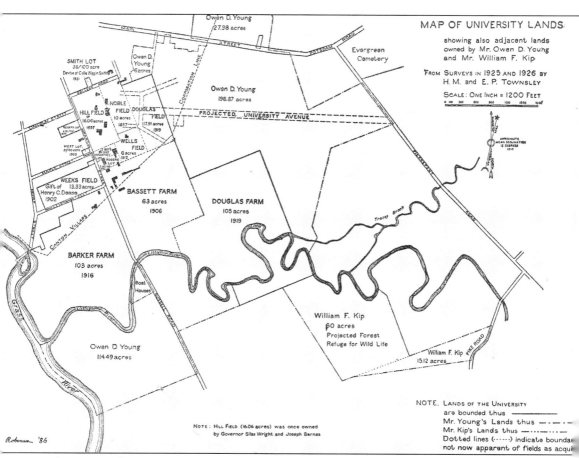

The vision of Owen D. Young allowed the university's expansion. This 1925–1926 map shows how Young's purchases led to the E. J. Noble Medical Building, MacAllaster House (the president's home), Appleton Golf Course, Elsa Gunnison Appleton Riding Hall, and residential developments on Hillside Drive and East Main Street. The land on which many of the major campus buildings stand was once owned by Silas Wright, a U.S. senator and New York governor. The Kip Tract is part of the Little River Nature and Recreation Area. Today's campus has over 1,000 acres.

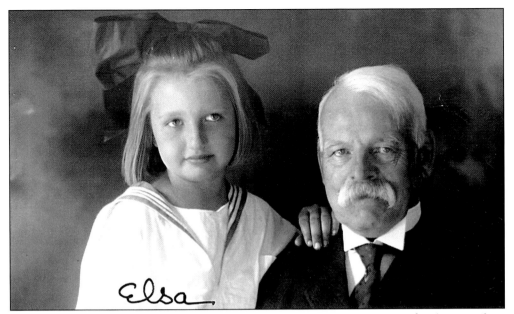

Elsa Gunnison '26 is pictured with her grandfather Almon Gunnison 1868, the president of St. Lawrence. She married Oliver D. Appleton '27. Three campus buildings bear the Gunnison or Appleton name: Gunnison Memorial Chapel, Appleton Arena, and the Elsa Gunnison Appleton Riding Hall.

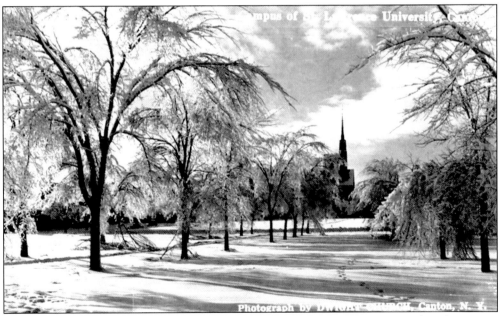

Pictured is the Avenue of the Elms as it appeared after an ice storm. The elms were planted in the 1920s, after Owen D. Young purchased land for the college's future growth. The elms succumbed to Dutch elm disease in the 1950s and 1960s and were replaced with red maples.

Dean-Eaton Hall (1926) was for many years the residence for first-year women. Rules were strict: 10:00 p.m. curfew (except midnight on Saturday), no radios, no calling out of the dorm windows, and supervised study halls. Residents dined in the current first-floor lounge and worried about "the freshman 15" weight gain. The rules were enforced by the dean of women and the Women's Student Government Association. Violators were campused (confined to the campus and not allowed to date).

Brewer Field House, St. Lawrence University, Canton, N. Y.

Brewer Field House was built in the 1920s and named for trustee Charles Brewer 1891. Until the 1960s, Brewer housed offices for all the male coaches, the training room, locker rooms for home and away teams, spectator seating, and the basketball court. St. Lawrence students in the balcony were known to dangle snowy, dripping boots over the heads of the opposing team, seated directly below.

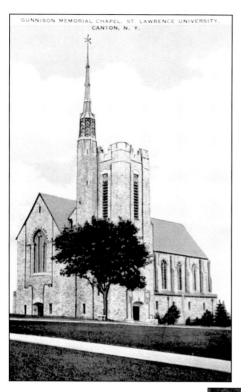

GUNNISON MEMORIAL CHAPEL, ST. LAWRENCE UNIVERSITY,
CANTON, N. Y.

This is an exterior view of Gunnison Memorial Chapel (1926). Almon Gunnison was a Universalist minister who became president of St. Lawrence during the "Epoch of Expansion," 1899–1915.

The chapel was for many years the center of campus life. It was the location for songfests, visiting speakers, and Tuesday morning chapel. In the 1950s, chapel attendance was mandatory; students who did not attend lost academic credit.

Madame Marie Curie, discoverer of radium, dedicated Hepburn Hall in 1929. As part of the ceremony, the honored guest planted a blue spruce with a shovel known as the Curie Spade and used ever after for groundbreakings. The students celebrated the famous scientist by shouting a college cheer that ended with "Fight! Fight! Fight! Madame Curie!" Hepburn Hall is named for Emily Eaton Hepburn, a trustee for 60 years.

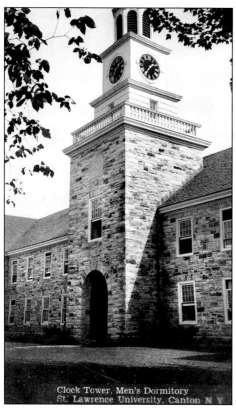

Clock Tower, Men's Dormitory
St. Lawrence University, Canton N Y

For many years the Sykes Residence Clock Tower was the symbol used on St. Lawrence publications. At its beginning Sykes was called Men's Residence ("Men's Res," by the students) and it was home to first-year men. It was the domain of Alice Poste "Ma" Gunnison and then Harriet "Ma" Burgess, housemothers who set the disciplinary and social standards for "their boys." They provided some semblance of order and matronly guidance for young men, many of whom were rural boys away from home for the first time.

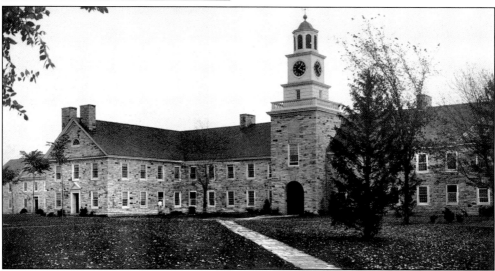

Owen D. Young 1894 raised the money for the building of the men's dormitory. He was chairman of the board of General Electric Company, founder of the Radio Corporation of American, leader of World War I reparation efforts, and chairman of the St. Lawrence Board of Trustees. It is said that if St. Lawrence needed so much as a hammer, Young would drop all of his business pursuits and produce one. He asked several of his wealthy friends, including the Mellons and George F. Baker, to give the money for the dormitory, now called Sykes Residence.

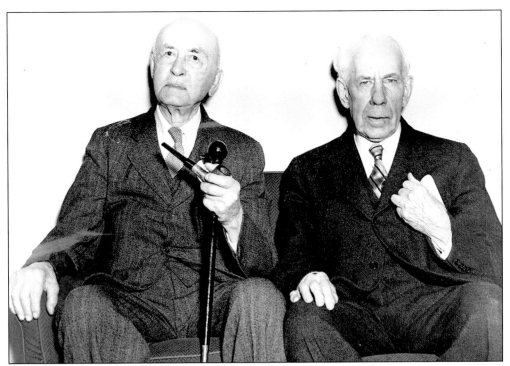

Grosvenor Swan Farmer 1871 (left) and novelist Irving Bacheller 1882 talk things over at St. Lawrence University's 89th commencement in 1946. Quipped the 96-year-old doctor to the younger novelist, "It's amazing the way you old fellows get out for these affairs." Bacheller was the author of *Eben Holden*, said to be America's first 20th-century best seller.

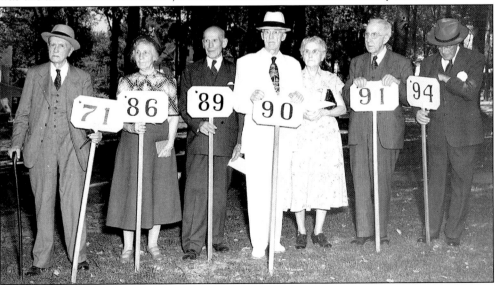

In this 1949 commencement photograph, Emily Eaton Hepburn, for 60 years a St. Lawrence trustee, holds the class of 1886 sign. When Hepburn Hall was planned, Owen D. Young preferred another location to her choice. Mrs. Hepburn is said to have remarked sweetly, "Why, Owen, we don't have to build it at all." She had her way. On her left is John Murray Atwood 1889, dean of the Theological School.

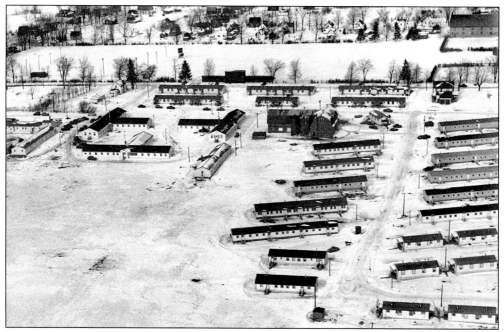

World War II caused extreme hardships for the college. By 1945, the student body had shrunk to 300 and the highest-paid faculty member earned $3,600. Following the war, the GI Bill allowed thousands of veterans to flock to college campuses. St. Lawrence's enrollment doubled immediately after the war, and within 10 years it had tripled. Returning veterans, many of them married and with families, lived in Vetsville—flimsy army surplus housing. The area to the left housed young faculty and was known as Faculty Court. This area is now the athletic complex and fields.

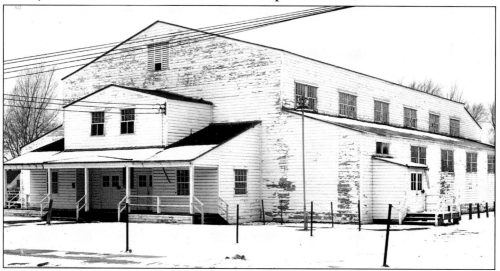

This shabby World War II relic is Laurentian Hall, the student union of the 1940s and 1950s. It was home to movies, plays, dances, and concerts. When the E. J. Noble University Center was built in 1962, Laurentian Hall was no longer needed, and it was razed. Two fraternity houses, Sigma Chi and Phi Kappa Sigma, were built on this Maple Street site; these former fraternity houses are now residences for first-year colleges.

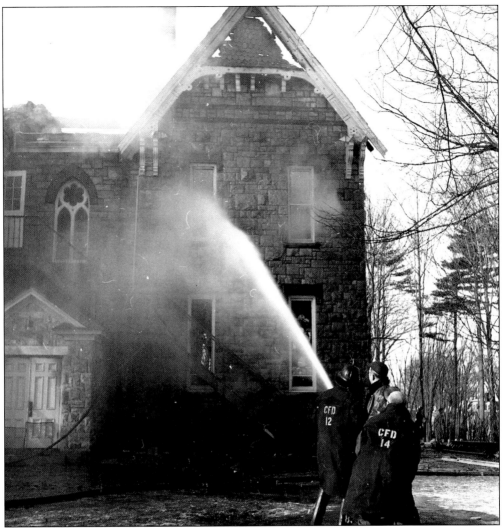

In 1951, a fire destroyed Fisher Hall, the home of the Theological School. In 1954, Atwood Hall was built to replace it. In 1965, the Theological School left St. Lawrence to affiliate with Tufts University. Since then Atwood Hall has been the home of the Education Department.

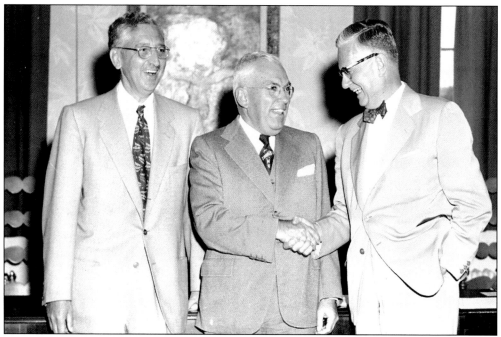

From left to right are Pres. Eugene G. Bewkes (pronounced "bew kiss") and two successive chairmen of the St. Lawrence Board of Trustees, Homer A. Vilas '13 and Edward John Noble. All three have major campus buildings named for them.

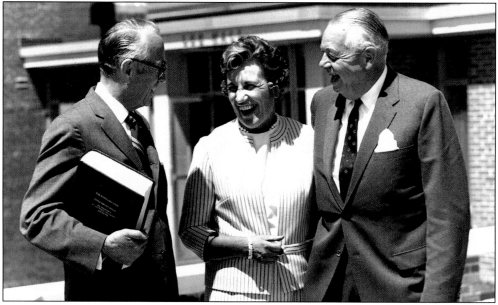

From left to right are Pres. Foster S. Brown '30, Kay Brown, and Arthur S. Torrey '23, chairman of the St. Lawrence Board of Trustees, enjoying a light moment. A wing of Owen D. Young Library was named for Torrey, a generous benefactor. Brown was a builder; under his leadership Vilas Hall, Griffiths Arts Center, Bewkes Science Hall, and Augsbury Physical Education Center were constructed. During his presidency, student enrollment swelled; typical entering classes were about 650.

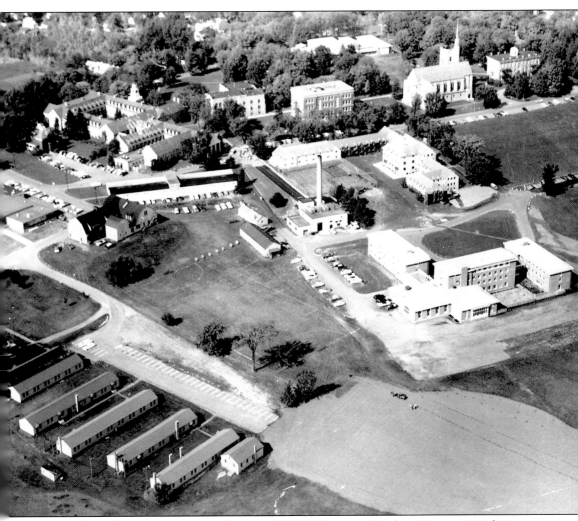

This is how the campus appeared around 1960. The new Student Center (2004) is on the former sites of South Hall, a World War II prefabricated structure, and the "Aggie School" barn (left center). Students who had history and government classes in South Hall remember sitting next to uninsulated windows and freezing from the waist up while their lower extremities boiled from the heat of the floor radiators.

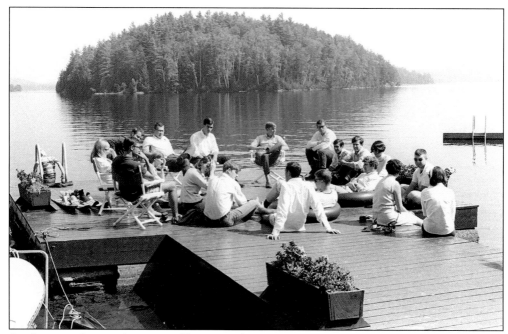

Students gather with Ron Hoffmann '54 (wearing glasses, with his back to the lake) on the dock at Canaras Conference Center on Upper Saranac Lake in the Adirondacks. Hoffman was the Canaras director and longtime football and cross-country coach. St. Lawrence uses Canaras for summer trustee and Alumni Council meetings, for student conferences, and as a vacation retreat for alumni families.

This is the road to Hulett Lodge, a rustic retreat used for student picnics and meetings. Hulett Lodge was in a grove of trees past the Little River bridge and near the Sandbanks, a popular swimming hole in the Grasse River. Hulett Lodge was razed in the 1970s.

# *Two*

# ACADEMIC PROGRAMS

Ebenezer Fisher
began the Universalist
Theological School
in 1858 with four
students. He was
described as "rock-
like in his principles
and crystalline in his
character . . . a great and
benign personality who
overshadowed all others
on the Hill." He served as
president of the school
for 21 years.

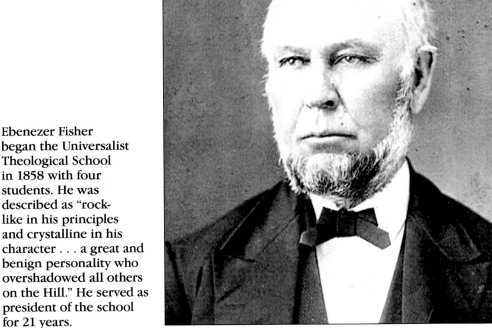

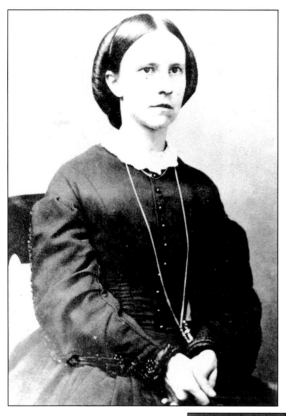

Olympia Brown attended Mt. Holyoke College and graduated from Antioch College before graduating from the St. Lawrence Theological School in 1863. She was the first woman in the United States to be ordained as a minister and was an early crusader for women's suffrage.

When the New York State Legislature granted a charter to St. Lawrence University in 1856, it established both a Universalist Theological School and a College of Letters and Science. The Theological School began accepting students immediately, and the first students were graduated in 1859. Because there were no students deemed to be qualified to enter the College of Letters and Science, John Stebbins Lee, a Universalist minister, was asked by the college's trustees to establish a Preparatory Department. The College of Letters and Science graduated its first students in 1865.

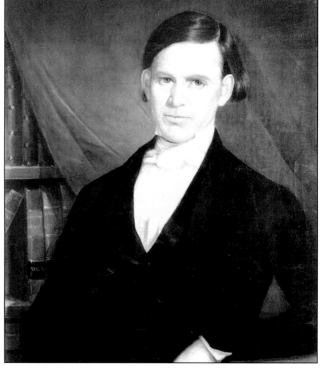

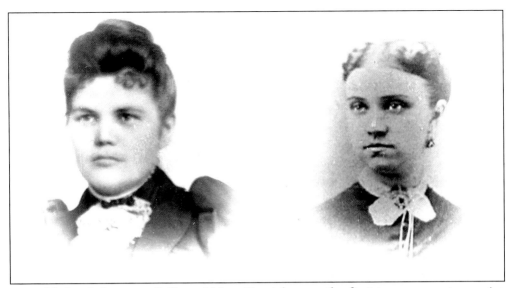

In 1866, Sarah Sprague (left) and Mary Herrick were the first two women to receive the diploma of St. Lawrence University. The university's trustees created two McCurdy-Sprague board positions for graduates of the previous 10 years. These positions are named for Sprague, who had a distinguished career as an educator and author, and Delos McCurdy, who had a career in law and was one of two men to receive a St. Lawrence degree in 1865.

Isaac Murray Atwood was a Universalist minister and newspaper editor in Boston. In 1879, he succeeded Ebenezer Fisher as second president of the Theological School. Until Fisher Hall was built in 1881, the Theological School and the College of Letters and Science were both located in College Hall (now Richardson Hall).

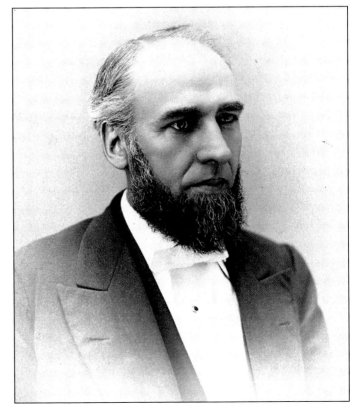

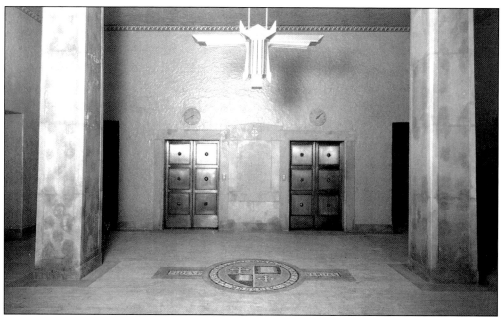

The Law School of St. Lawrence University was chartered in 1869. Among the early faculty were Stillman Foote, probably the son of Canton's first permanent settler, and Leslie W. Russell, a prominent local judge. In 1903, Brooklyn Law School and St. Lawrence joined forces. In 1928, at its peak, the Brooklyn Law School of St. Lawrence University enrolled 3,312 students and was the largest law school in the country. In 1943, St. Lawrence University and Brooklyn Law School became separate institutions.

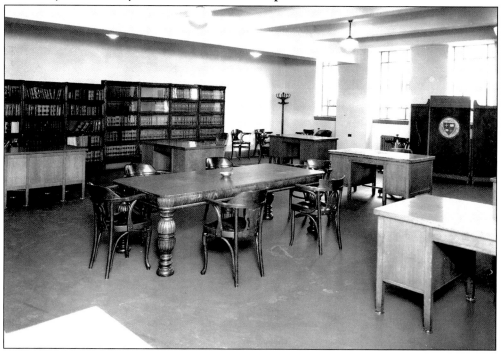

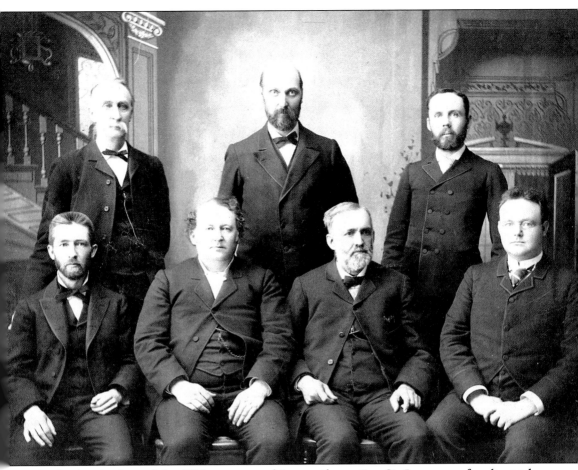

At the beginning of the 20th century, this was the entire St. Lawrence faculty and administration. There were 17 graduates in the class of 1900. This was a time when only one percent of high school graduates went to college and college presidents traveled the countryside by horse and buggy, attempting to recruit promising students. Among subjects taught were Greek, Latin, moral philosophy, rhetoric, and civil government.

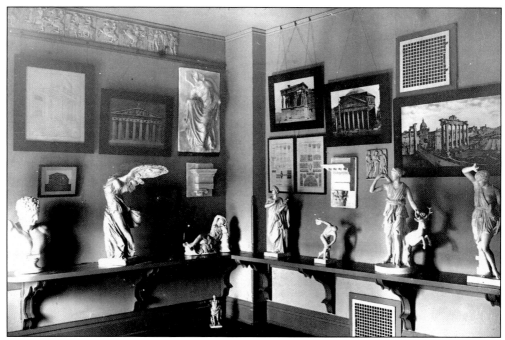

This *c.* 1912 photograph is of Prof. George R. Hardie's fine arts room on the second floor in Richardson Hall. Hardie, who joined the faculty in 1898, was head of the Latin Department and taught the course in freshman English. While many of the early faculty had advanced training, none was a doctor of philosophy.

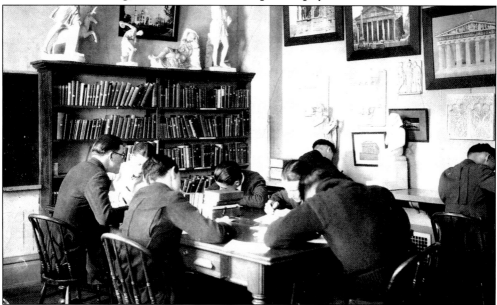

A study group, probably before 1925, works in the fine arts room of Richardson Hall. These men may have been working on an assignment from Charles Kelsey Gaines, professor of classics. Charles Kelsey Gaines was noted for the aggressiveness with which he evaluated student papers in class. He sometimes began his class with, "By far the worst of these papers is that of Mr. [or Miss]. . . ."

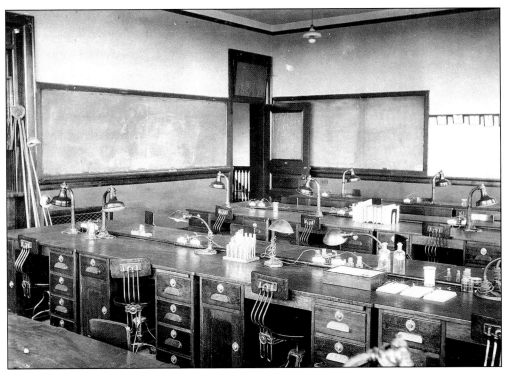

This early biology lab was located on the top floor of Carnegie Hall.

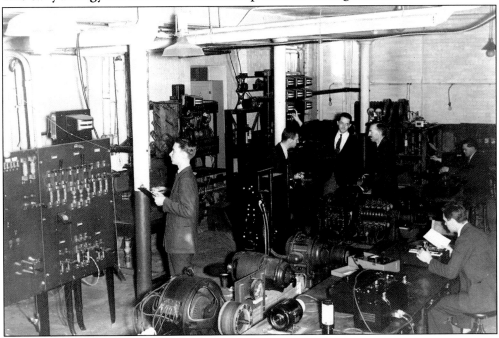

This *c.* 1940 electrical lab was located in Carnegie Hall. In the center are George Hazzard '36 and Prof. Ward Priest '07. Hazzard, who taught at St. Lawrence, became a university trustee and president of Worcester Polytechnic Institute. Priest taught physics at St. Lawrence for 44 years.

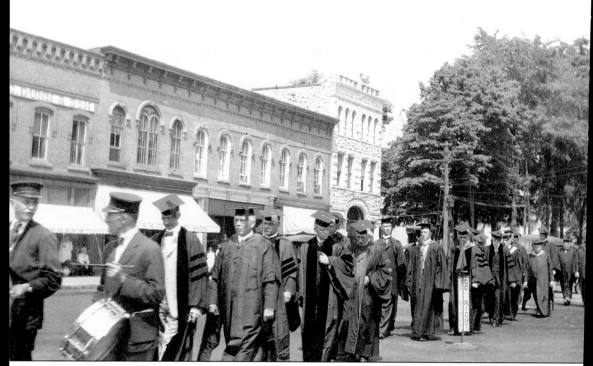

An academic procession wends its way through Main Street to graduation ceremonies in Canton Town Hall sometime before 1928. In the early years, students spent more time downtown than they do today. Commencement and other college ceremonies were held downtown; shopping was downtown; also, students took rooms in village homes, and because their numbers were so few, they got to know many of the villagers.

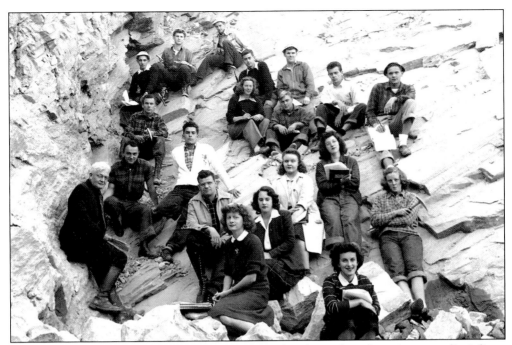

This is a geology field trip in 1942. St. Lawrence faculty and students in many disciplines have considered the North Country a vast outdoor learning laboratory.

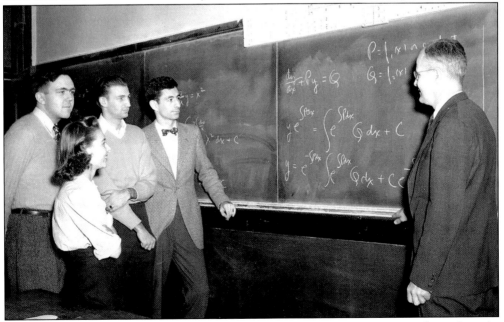

This picture shows O.K. Bates, head of the Mathematics Department, with students in 1946, when the standards of student and faculty dress were obviously higher than they are today. Bates taught from 1933 to 1967 and initiated 3:2 engineering programs with Massachusetts Institute of Technology, Columbia University, and Rensselaer Polytechnic Institute. The slide rule, on the top of the chalkboard, was used for calculations before the invention of electronic calculators.

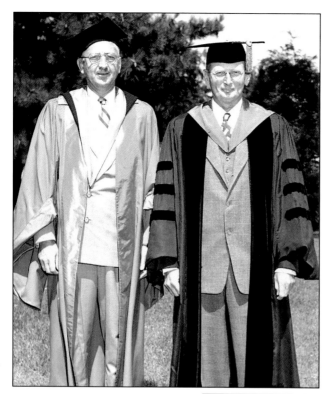

Eugene G. Bewkes (left), president from 1945 to 1962, is pictured here with Prof. Henry "Harry" Reiff, for many years head of the History and Government Department. Reiff helped to draft the United Nations Charter and wrote the definitive book on maritime treaty law. The science facility is named for Bewkes; Reiff College, one of the first-year living and learning residences, honors Reiff.

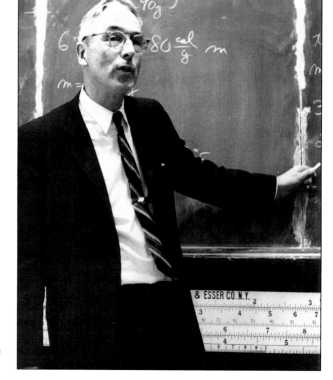

Prof. Alfred Romer, Priest Professor of Physics, lectures to a class. Romer's book *The Restless Atom* was translated into 13 languages. In his honor, the university established the Romer Lecture Series, in which leading scientists are brought to the campus.

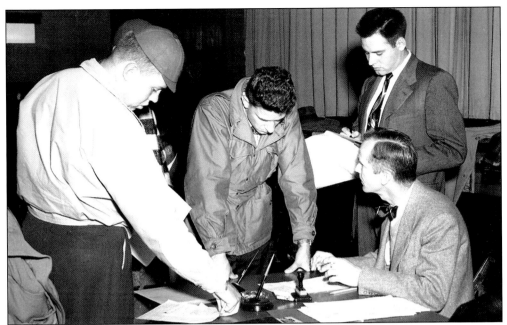

This was the way in which students registered for classes in 1950. Seated is G. K. Brown, dean of men. The student on the left is wearing his freshman beanie, and around his neck is a large sign with his name and hometown. Wearing beanies and signs was enforced by the L Club, the letterman's organization. Freshmen could stop wearing beanies and signs after Thanksgiving or after the first home football victory, whichever came first. In the late 1950s, there was a 24-game losing streak.

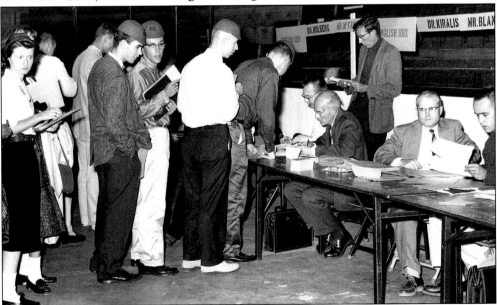

These nervous freshmen registering in Appleton Arena face a formidable foursome from the English Department. From left to right, seated, they are Professors Karl Kiralis, Paul F. Jamieson, Douglas R. Angus (standing), and Edward J. Blankman. Jamieson was a noted authority on the history and geography of the Adirondacks.

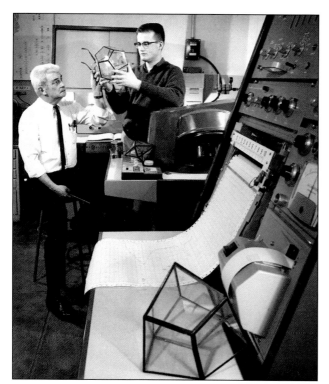

Robert O. Bloomer works in his geology lab in 1969. Bloomer was sufficiently colorful that *Look* magazine did a feature story on him called "The Rock Doc." Bloomer told the magazine editors that St. Lawrence County was so barren that it took an acre to pasture one rabbit but that the area was a geologist's paradise.

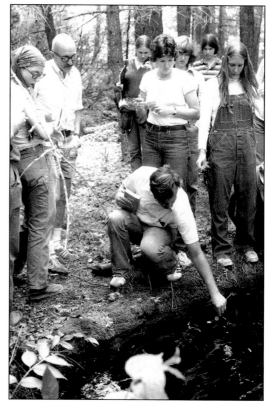

Prof. John I. Green is shown here conducting a biology lab "in the field." Green, a naturalist who joined the faculty in 1965, continues to lead field trips for alumni, schools, and clubs.

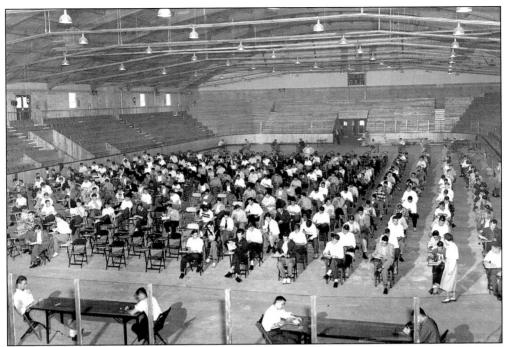

A final exam is being administered in Appleton Arena in 1966. In the 1950s and 1960s, a typical course required three "prelims" (hour-long-exams), one paper, and a three-hour final exam. During these years, most faculty members lectured for 50 minutes and there was little class participation.

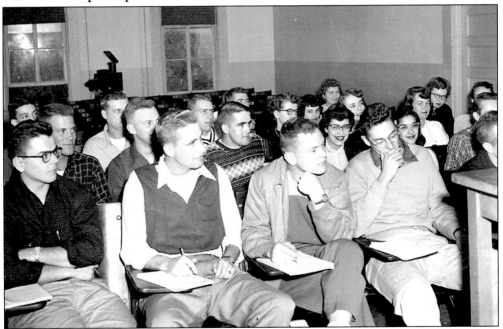

This classroom scene is portrayed in the 1953 *Gridiron*, the college yearbook. In the 1950s, students sat in rows and took notes while the professors lectured. Desks, chairs, and lighting were strictly utilitarian.

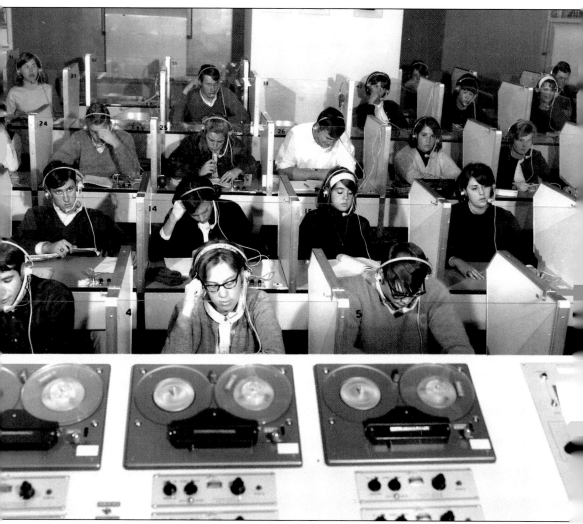

In 1966, this was a state-of-the-art language laboratory. This "advanced technology" was thought to teach foreign languages more effectively than traditional lecture and recitation methods because students got immediate feedback on their pronunciation and they could repeat lessons as often as they wished.

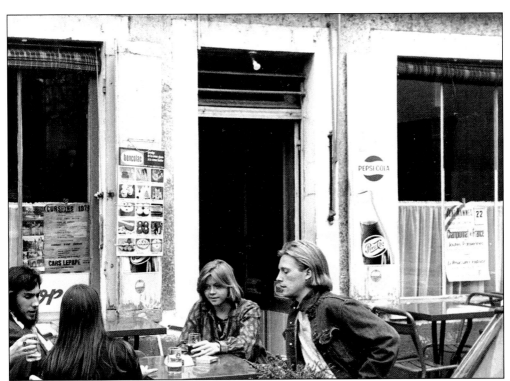

Students pose on the streets of Rouen, France. St. Lawrence was a pioneer in study abroad programs, begun in the 1960s. The first programs, initiated by Prof. Oliver Andrews, head of modern languages, were in France, Spain, and Austria. The flagship Kenya program was begun in 1974. Today, international study opportunities are available throughout the world, including programs in Australia, Austria, Canada, China, Costa Rica, Denmark, England, France, India, Italy, Japan, Kenya, Spain, and Trinidad and Tobago.

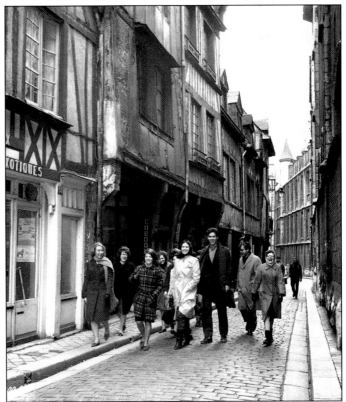

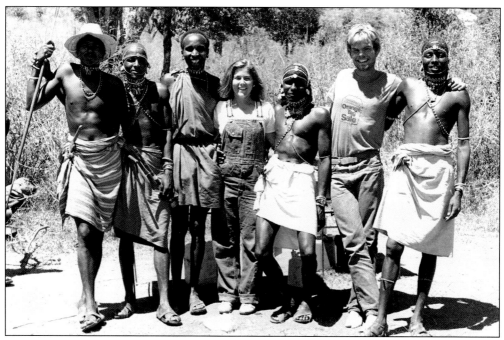

Elizabeth Nordell '83 and Roland Jacobs '83 are pictured with Samburu warriors in Kenya in 1981.

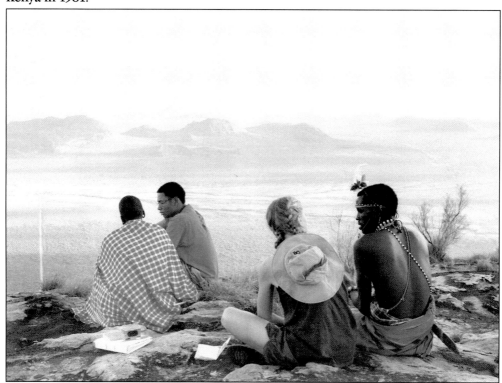

Samburu elders and students on the Kenya Semester Program discuss rainfall patterns in northern Kenya.

# *Three*

# CAMPUS LIFE

This is a scene from *The Rivals*, an 1898 student production presented by actors from the college and the village. Early plays were produced in French, Latin, or English. The Browning Society (later, the Kappa Kappa Gamma sorority) presented the first St. Lawrence dramatic productions, two farces, in 1875. Fraternity and sorority groups evolved from literary societies or dramatic clubs.

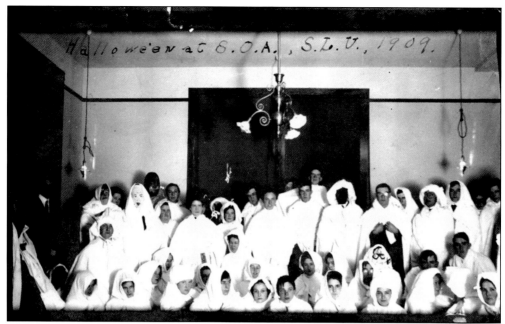

This 1909 Halloween party was at the School of Agriculture. Chartered in 1906 as part of St. Lawrence University, the School of Agriculture evolved into Canton Agricultural and Technical Institute, which then became Canton Agricultural and Technical College, a two-year branch of the State University of New York. When the two-year branch moved to a new location across town and became State University of New York at Canton, St. Lawrence purchased the buildings, including Cook (now Piskor), Payson, Valentine, Brown, and Madill Halls.

Albert B. Corey is tapped for Kixioc, probably in 1933. As a professor, Corey originated the Canadian-American conferences that took place alternately at St. Lawrence and Queens University, Kingston, Ontario. St. Lawrence was one of the first American colleges to recognize the importance of U.S.-Canadian relations.

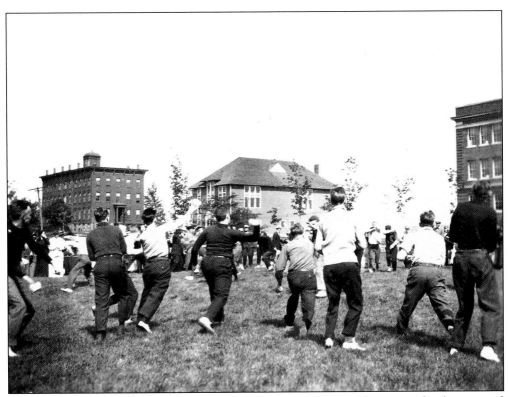

This 1912 free-for-all was part of an ongoing competition between freshman and sophomore men. The competition was sometimes referred to as the Cane or Salt Rush, in which bags of salt were thrown at the opposition and students whacked each other with canes. This physical rivalry continued into the 1930s. During these years a large medicine ball was placed in the center of Weeks Football Field and each class tried to roll it over the other's goal line, no holds barred.

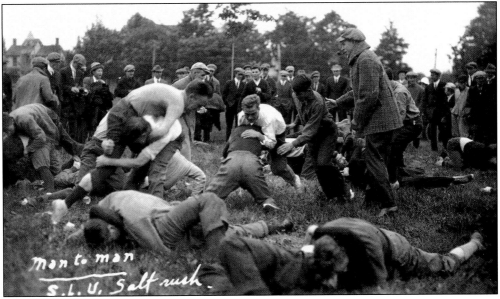

man to man
S. L. U. Salt rush.

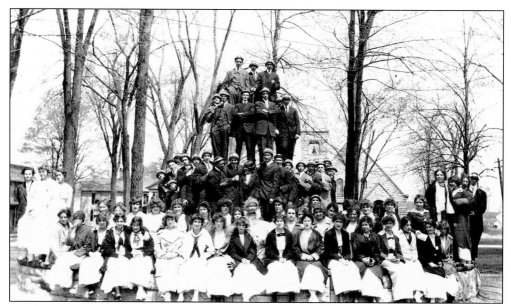

Students in the village park celebrate Moving-Up Day in 1914. Moving-Up Day is a time for recognizing student accomplishments. John D. Brush Sr. '22 and Harry Shilkret '21 wrote the traditional Moving-Up Day song, "Weaving in and out the Rows."

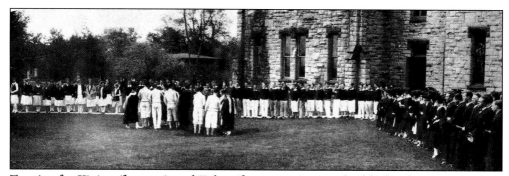

Tapping for Kixioc (for men) and Kalon (for women) was a highlight of Moving-Up Day. This scene is in front of Fisher Hall. Tapping usually took place on the triangular walk between Richardson and Herring-Cole. Juniors and seniors with outstanding scholarship and leadership were recognized. Kixioc became the national honor society Omicron Delta Kappa; Kalon became Mortar Board and then Omicron Delta Kappa.

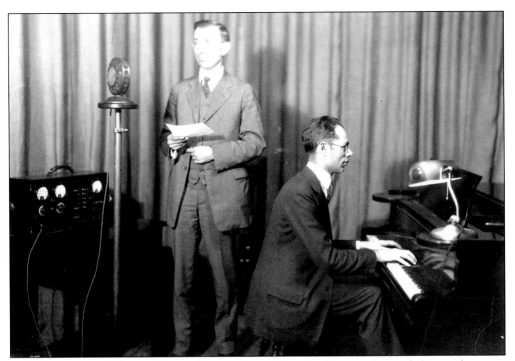

WCAD was one of the earliest college radio stations in the country and the predecessor to KSLU, the student-operated campus station. At the microphone is Prof. Ward Priest of the Physics Department, who was instrumental in starting the station. The pianist was Frank M. Cram. In the 1950s and 1960s, an academic curriculum in radio and television was taught by Bill Creasy '52. Creasy Way, the walkway in front of the athletic complex, and Creasy Commons, the site of commencement, are named in his honor.

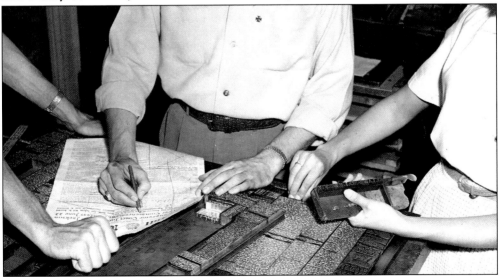

These students are working on the *Hill News* layout. The student paper has been published since 1911. From year to year, the paper reflects both the disposition of the editorial staff and the pulse of the campus. At the time of this picture, the type was set by hand at the Commercial Press in downtown Canton. The type is now set electronically.

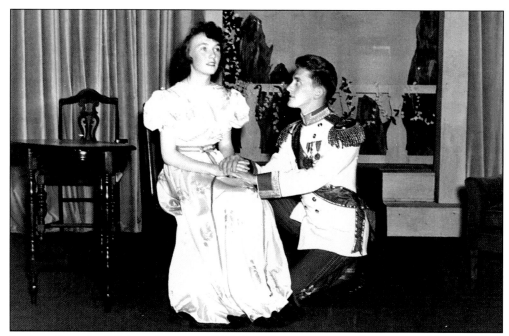

Isadore Demsky '39, later known as Kirk Douglas, appears with Mary Coakley in *Death Takes a Holiday*. The recipient of an honorary Oscar, Kirk Douglas was ranked 53rd of the top 100 movie stars of all time. He returned to his alma mater to receive an honorary degree in 1958, and he gave the university $1 million to establish scholarships for minority students in 1999.

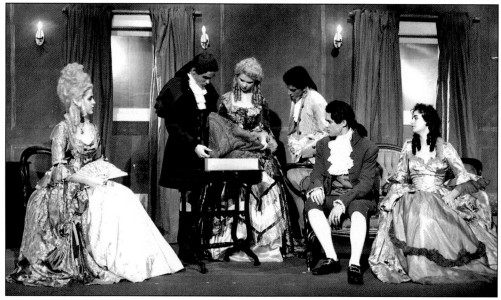

Marguerite G. Holmes directed this production of *Berkeley Square*. According to the college history *The Scarlet and the Brown*, "Under primitive conditions [in truth a barn] she directed students in construction of scenery beside an old wood-burning stove. She and her loyal thespians overcame depressing conditions in Laurentian Hall to stage inspiring productions."

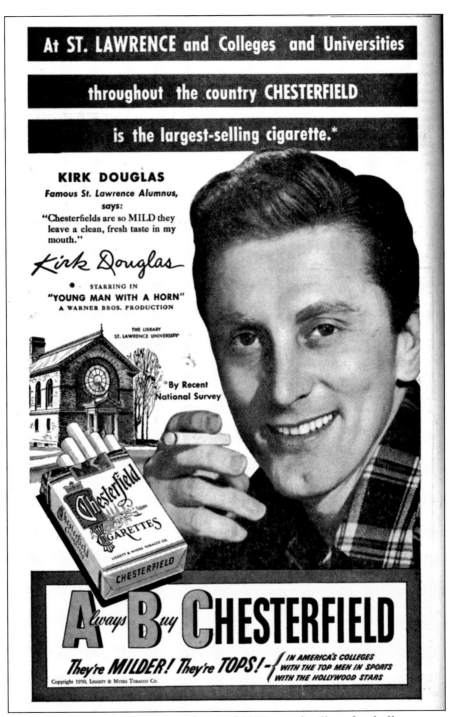

Cigarette companies in the 1930s, 1940s, and 1950s used college football stars, campus beauty queens and movie stars to advertise in national magazines such as *Look*, *Life*, and the *Saturday Evening Post*. The picture here shows Kirk Douglas endorsing Chesterfield cigarettes in a *Hill News* advertisement from 1950. The advertisement includes a picture of the St. Lawrence library.

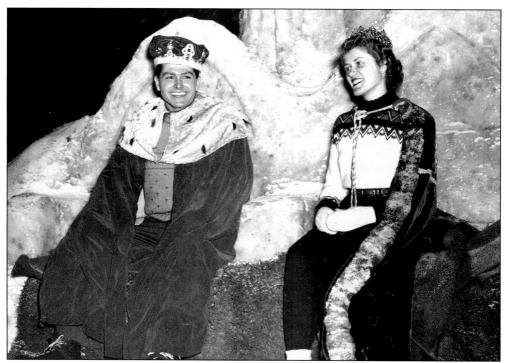

The Winter Carnival king and queen were elected by the student body. Enjoying the moment are King Newcomb "Newk" Steuart '51 and Queen Eleanor DeWitt '51. Winter Carnival was the highlight of the college year. Begun in 1934, it featured snow sculptures, ski races, an intercollegiate songfest, and a Winter Carnival Ball with big-name dance orchestras such as Lester Lanin, Billy Butterfield, and Les Elgart. This throne was on the football field.

Snow sculptures were a big part of Winter Carnival; fraternity and sorority members and pledges spent hundreds of hours trying to win the snow sculpture competition. This snow sculpture was an entry in the Winter Carnival of 1948 or 1949.

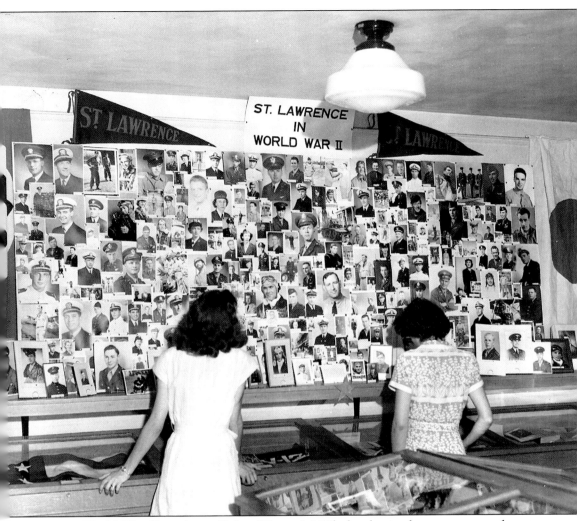

During World War II, registrar Helen "Tommie" Whalen kept a busy correspondence with St. Lawrence's men and women in uniform. This bulletin board displayed some of the photos that the fighting Laurentians sent back to their Alma Mater. A total of 47 St. Lawrence men were killed in World War II. So many faculty and students enlisted that the college almost closed.

Harvey Eggleston '10, Freddie Lynn (sponsor), and Royal Milligau '08 took part in the christening of the S.S. *St. Lawrence Victory*, on March 17, 1945, in Richmond, California. The ship was beached after striking a mine in the Mediterranean in 1947.

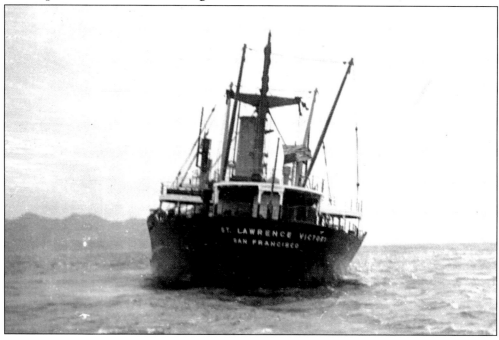

Since the 1920s, the bells in Gunnison Memorial Chapel have signaled the end of the academic day. The importance of the bells in the life of the campus is reflected in "Chapel Bells," a song by Eugene Wright '49, which begins, "Evening when the chapel bells ring out the ending of each day / We wonder what the future tells / When St. Lawrence bells no longer play." The carillonneur is Mara Crowell '78.

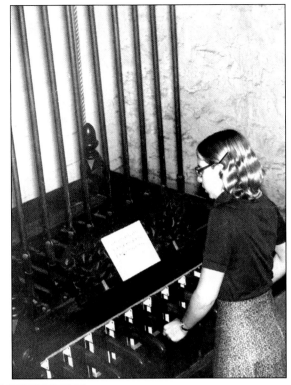

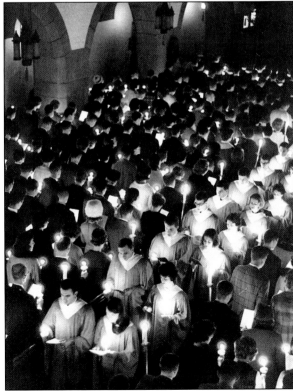

Many Laurentians have fond memories of the annual Candlelight Service, begun in the 1920s. Traditionally, the service is conducted in Gunnison Memorial Chapel just before the students leave for Christmas vacation. It usually features the Laurentian Singers and ends with "Silent Night" and the lighting of the candles.

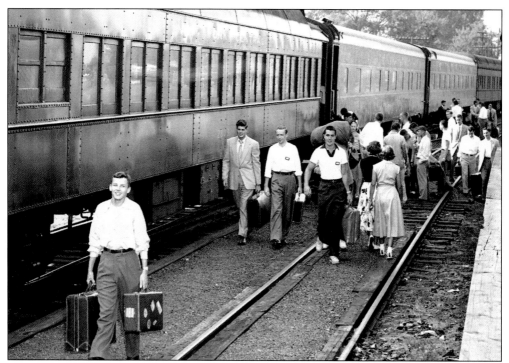

First-year students arrive at the Canton station on a special train in September. They uses the train because they were not permitted to have cars on campus. Until the 1960s, the school year began in mid-September and final exams for the first semester were in January. Commencement was in June.

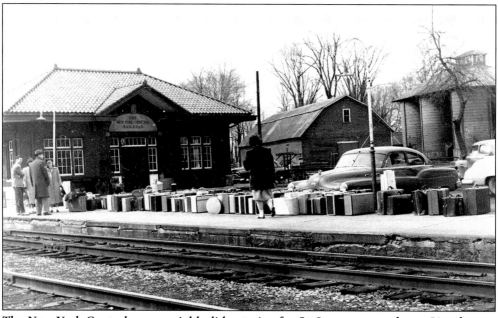

The New York Central ran special holiday trains for St. Lawrence students. Lined up at the Canton railroad station, these suitcases are headed home for Easter vacation in 1950. The train station is now the Hoot Owl bar.

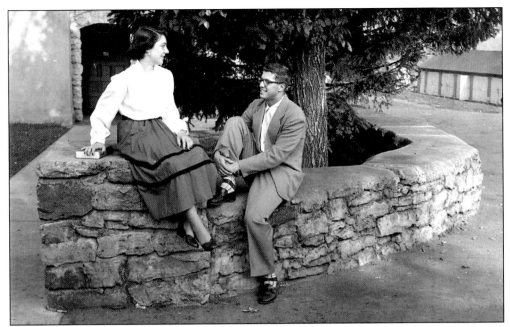

This 1950 photograph was most certainly posed for the campus photographer. For many years the door in the background led to the Snack Bar, a popular hangout. Students often arranged to meet at the Snack Bar wall. Nobody has kept statistics, but there is no doubt many campus romances led to marriage.

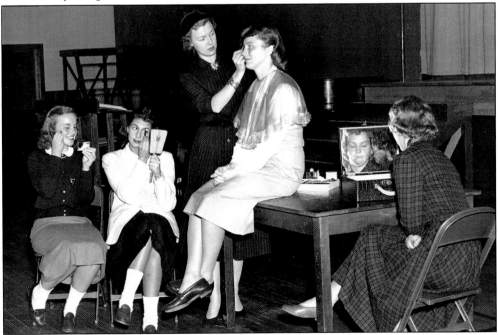

Makeup, manners, and proper attire were serious business in the 1940s and 1950s. This is a 1951 grooming class in Laurentian Hall. The Women's Student Government Association, encouraged by the dean of women, sponsored clinics at which young ladies were coached on how to look and how to act.

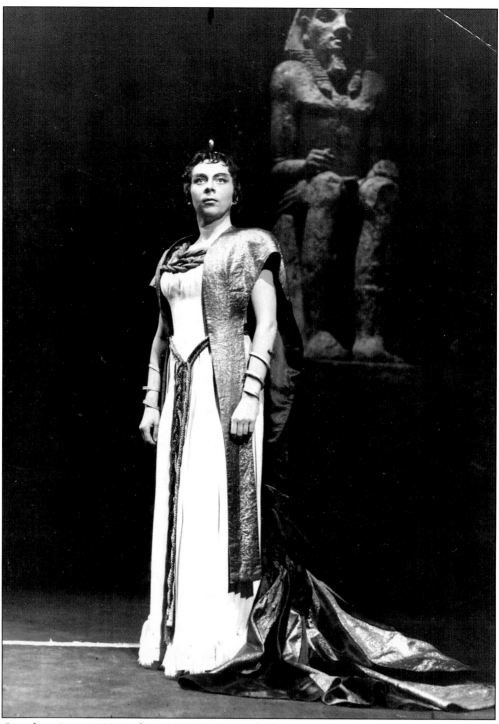

Gretchen Bence '50 performs in *Caesar and Cleopatra*. She later performed with the Robert Shaw Chorale and became a well-known opera singer.

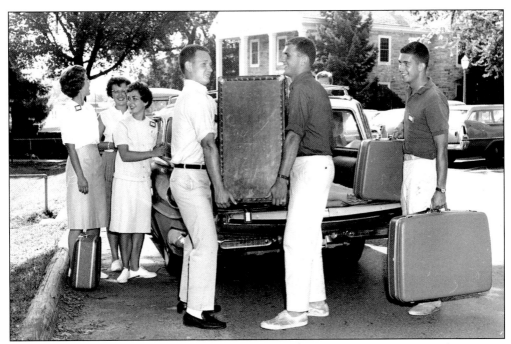

Orientation leaders greet arriving freshmen in 1961. For many years it was the custom for upper-class students to carry the trunks and suitcases of freshmen to their rooms. All first-year men lived in the Men's Residence (Sykes Hall), and all first-year women lived in Dean-Eaton Hall.

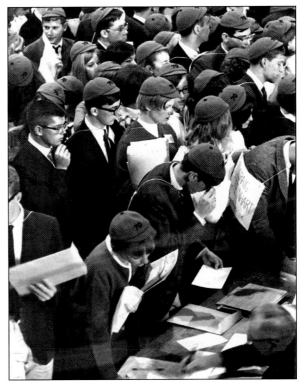

Registration for freshman classes was chaotic. Before electronic registration was possible, students crowded into Laurentian Hall or Appleton Arena to enroll in courses of their choice.

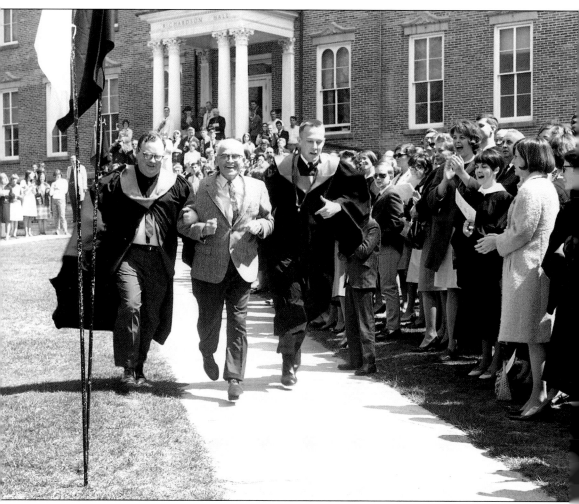

Alumnus Atwood Manley '16 (center) being tapped in 1967 for Omicron Delta Kappa by Robert Carlisle (left) of the History and Government Department and David Ford '67. Manley was the first alumni secretary at St. Lawrence. He was also editor of the *St. Lawrence Plaindealer*, Canton's weekly newspaper, and an authority on Canton natives Frederic Remington, the artist, and J. Henry Rushton, the famous canoe builder. It was said at Manley's memorial service that "Atwood always thought he would go to St. Lawrence when he died" because St. Lawrence was his idea of heaven.

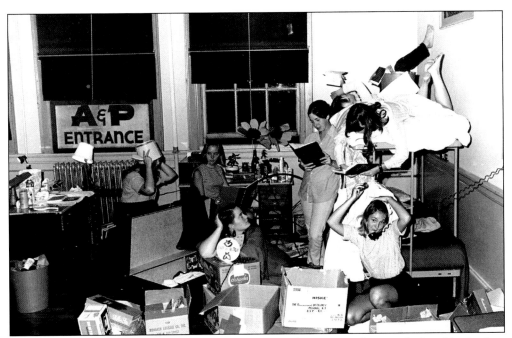

Carnegie Hall students ham it up for the photographer. Large classes admitted in the late 1960s and early 1970s required the conversion of Carnegie Science Hall into a student residence. Surprisingly, first-year women responded well to communal living.

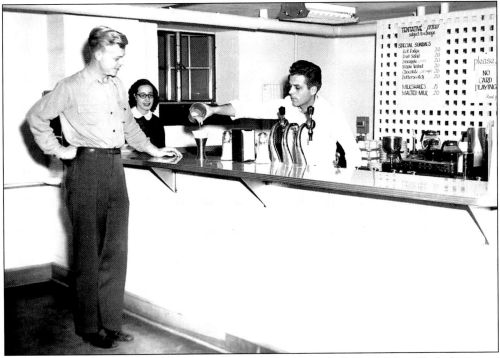

The Dean-Eaton Snack Bar, popular with students, was usually packed. Milk shakes were 15¢ and hot fudge sundaes 20¢. The "No Card Playing" sign was to encourage students to spend their money and move along.

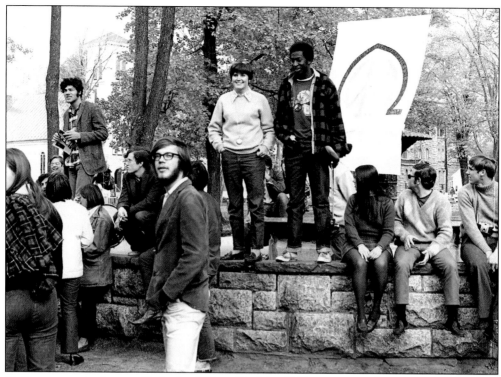

St. Lawrence students rally in the Village Park in 1969 to protest the Vietnam War. As at most campuses, the late 1960s and early 1970s were a time of turmoil at St. Lawrence. There were student rallies and demonstrations not only against the Vietnam War but also for parietal hours (visitation rights) and more representation in college governance.

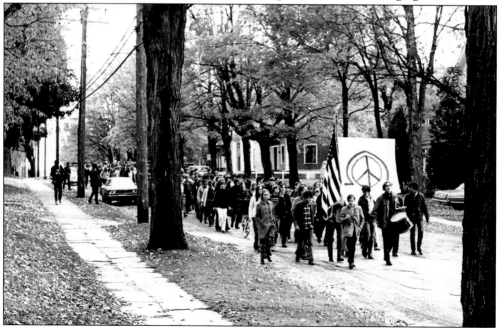

Anti-Vietnam war protesters march toward Canton's Main Street.

October 16, 1969, was a nationwide moratorium to protest the Vietnam War. While some students and faculty urged that the university be shut down, Pres. Frank Piskor stated that classes would not be canceled. Many students opted to attend religious services, parades, and speeches in Gunnison Memorial Chapel and in the Village Park.

Shakespearian scholar Thomas Berger of the English Department billed himself as "player, coach, owner, manager" of the English Department football team, a motley assemblage of faculty and administrators from all departments. The opposition was a revolving student team known as "the Pampered Jades." Berger published a scandalous weekly, the *English Department Football Team Newsletter*, which was eagerly anticipated on campus.

Students relax in Jencks Hall lounge, probably in 1975. When Hulett and Jencks Halls were built, they were known simply as Dorm 1 and Dorm 2. They were two-story structures built in a low-lying area near the golf course in 1954; students claimed they were originally three-story buildings but that the first story had settled into the mud. The commons building connecting the two dorms has been dubbed "Burger King" or "Pizza Hut."

On kitchen duty at the Eben Holden Dining Room in May 1973 are D. Kenneth Baker (left), dean of the college, and Frank P. Piskor, president. When Physical Plant and Food Services employees struck the university for 24 days, administrators and supervisors waited tables, cleaned pots and pans, mowed lawns, and cleaned toilets so the university could stagger through to commencement.

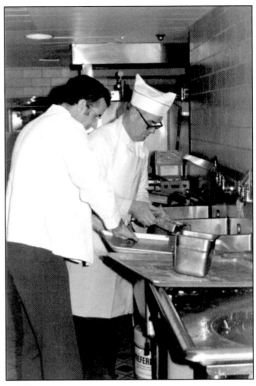

On duty in the E. J. Noble University Center Snack Bar are Peggy Ray (front) and Debbie Sheldon. Note the Schlitz tap. For a time in the 1970s, the New York State legal drinking age was 18, and the Snack Bar served beer to students.

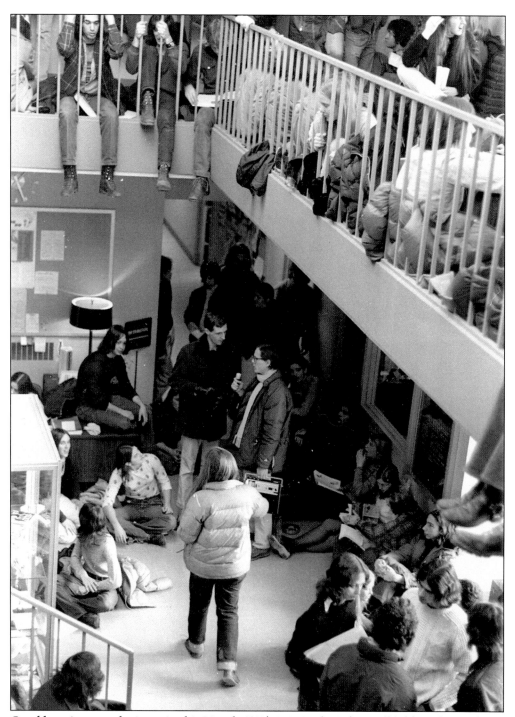

Coed housing was the issue in this March 1974 sit-in in the Vilas Hall lobby. The students wanted the dormitories open to both sexes. The "sit-in" was designed to wrench a positive decision from a reluctant Pres. Frank P. Piskor. Being interviewed in the center of the group is student leader Joseph T. "J. J." Jockel '74, later the Director of the St. Lawrence Canadian Studies program.

# *Four*

# ATHLETICS

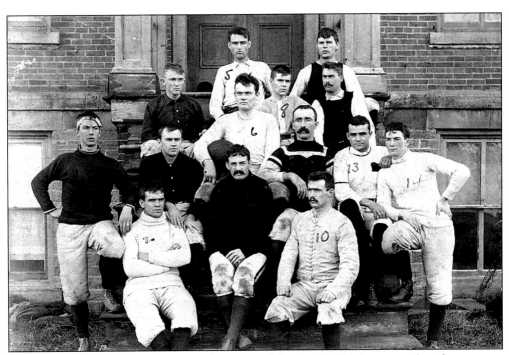

The 1892 football team relaxes on the steps of College Hall. The team played one game and was leading Potsdam Normal (now State University of New York, Potsdam) 18-0 when, according to St. Lawrence lore, the Normals, dissatisfied with an umpire's decision, refused to continue playing. St. Lawrence was declared the winner by forfeit.

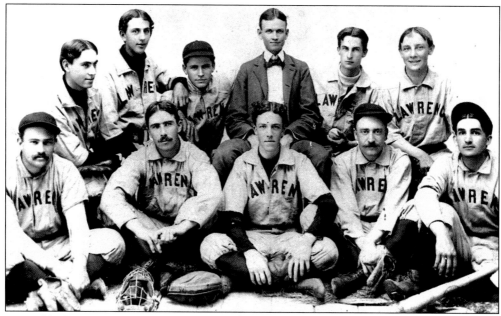

Assembled here is the 1896 baseball team. Bing Stevens, the grinning young man in the back right, later established the Bing Stevens store on East Main Street. This was the era of flimsy gloves, wooden bats, tiny catchers' masks, and sharp metal spikes.

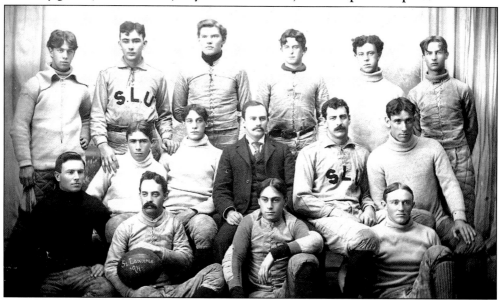

The first football game against another college was played at Colgate University in 1894. Colgate won 66-0. The average weight for the Colgate players was 175 pounds; St. Lawrence, 156 pounds. The 1906 team pictured here played on Weeks Field for the first time, defeating Cortland Normal, 32-0. The 1925 and 1950 teams have been the only undefeated teams. Teams from the 1930s opened the season with powerhouses such as Cornell, Syracuse, and Colgate Universities. Although in 1935 St. Lawrence upset Cornell, which had not had an opening-day loss in 40 years, there was usually little chance of winning. However, the gate receipts were welcome.

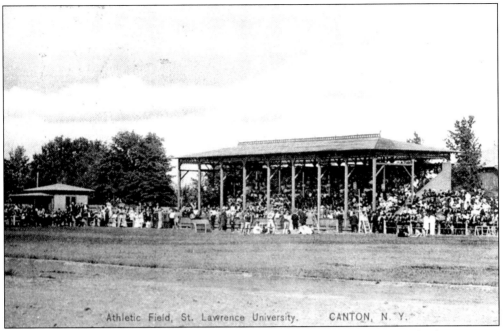

These *c.* 1909 postcards show the entrance and grandstand for Weeks Field. The entrance and grandstand inspired the retro look of Leckonby Stadium, the current venue for football and track.

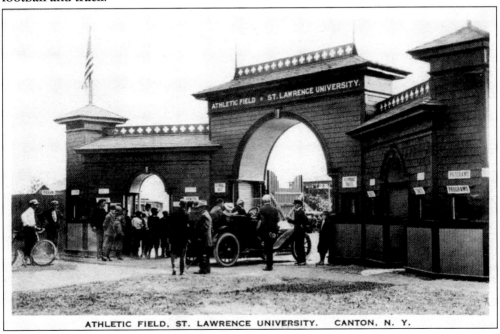

71

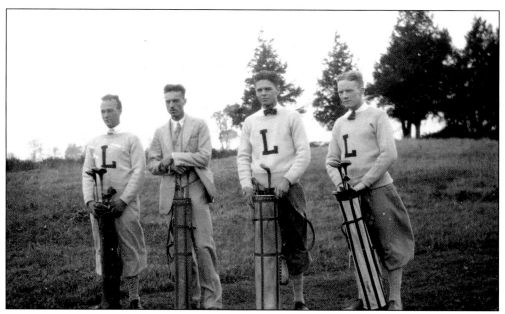

On the left in this 1926–1927 golf team photograph is Oliver D. Appleton. Note how few clubs golfers carried in that era. The university's original golf course, named for Appleton, had only nine holes. The course was expanded to eighteen holes in 1972.

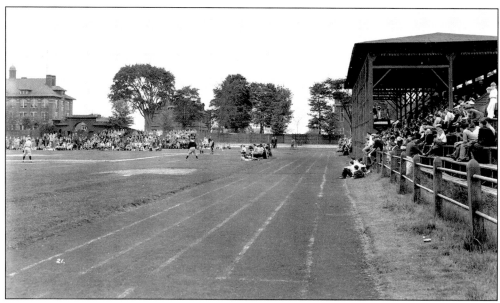

Weeks Field was used for baseball and track. The six-lane cinder quarter-mile track was in use from 1906 to 1935, when track was discontinued until the 1960s. The recently completed nine-lane Merrick-Pinkard all-weather outdoor track hosted the National Collegiate Athletic Association (NCAA) Division III national meet in 2003.

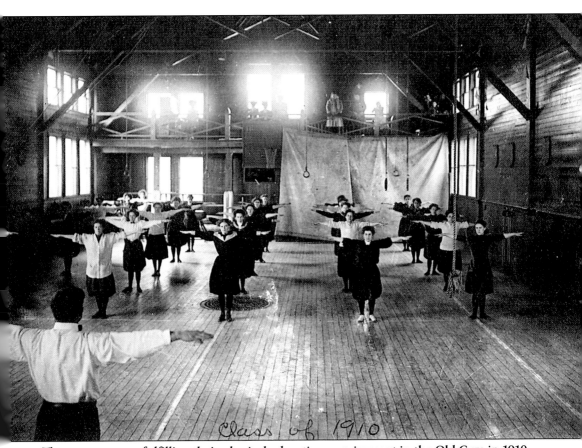

Class of 1910.

These women are fulfilling their physical education requirement in the Old Gym in 1910.

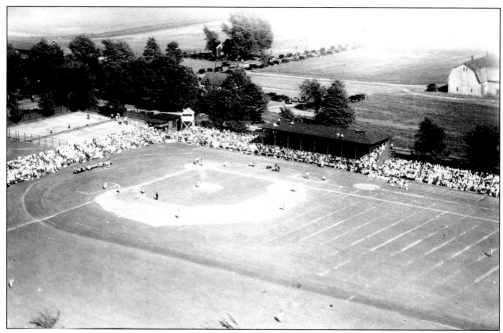

Before ice hockey and before television, the traditional American sports of baseball, basketball, and football drew the crowds. This could be a Weeks Field crowd watching the New York Giants honor Hal Schumacher's graduation in 1933 or one of the annual June Commencement Weekend doubleheaders played against Clarkson. The line of cars in the background stretches along Park Street.

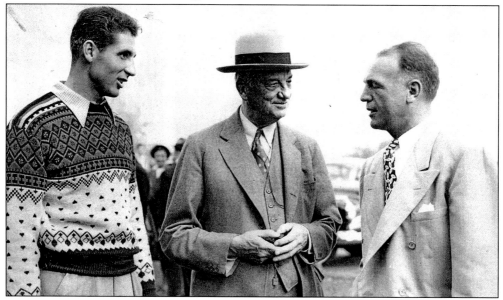

From left to right are Bobby Thompson, Owen D. Young 1894, and Hal Schumacher '33. Young was chairman of the St. Lawrence Board of Trustees. Thompson and Schumacher starred with the New York Giants professional baseball team. Thompson left St. Lawrence to play with the Giants and hit "the shot heard 'round the world," the home run that beat the Brooklyn Dodgers and put the Giants in the 1951 World Series.

74

This St. Lawrence quarterback sports a leather helmet and holds a bulbous football.

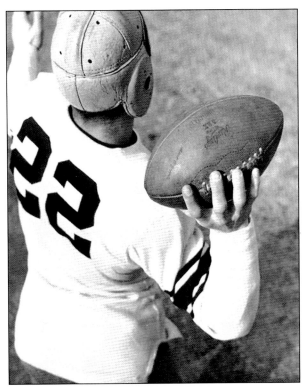

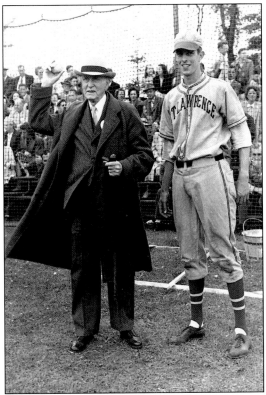

Grosvenor Farmer 1871 throws out the first ball in the Clarkson versus St. Lawrence game in 1946. Watching is pitcher John "Hooks" Hannon '46, who lost this game but beat Clarkson three times earlier in the year. Hannon became president of Bankers Trust and chairman of the St. Lawrence Board of Trustees.

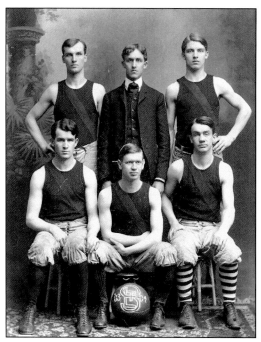

The 1904 basketball team beat Yale University. A St. Lawrence player "threw a foul" after 25 minutes of overtime to win the game 19-18. Early 20th-century St. Lawrence basketball teams beat Syracuse, Colgate, Manhattan College, and St. Johns University. It was not unusual for games to be so low scoring.

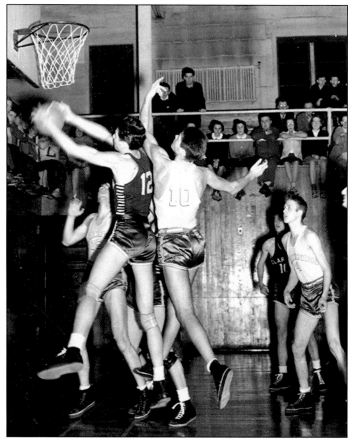

When basketball players wore short pants and black Converse sneakers, Brewer Bookstore was Brewer Field House.

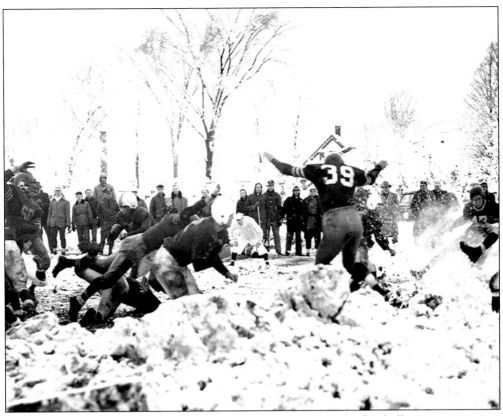

These photographs went coast-to-coast on the wire services. The football game was against Hofstra University in 1951, and the goal line was a three-foot snowbank. Spectators on skis watched from the sidelines; at halftime tractors plowed the field and the valiant band played on.

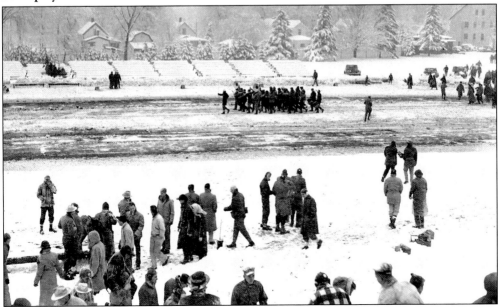

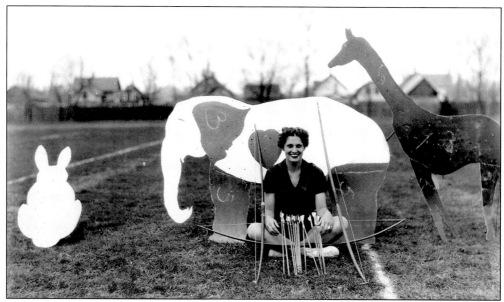

Big game cardboard cutouts of elephants, giraffes, and giant rabbits were used to train the champion St. Lawrence archery team. The coed archers held the eastern championship for three consecutive years. The archer is Janice H. Estill '49 of Mount Vernon.

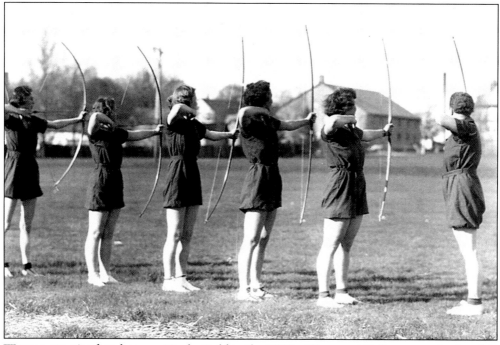

Women practiced archery on Weeks Field in the 1930s. Women at St. Lawrence during this era had required physical education, but women's intercollegiate sports—most notably basketball—had been discontinued. The administrative authorities decided that varsity women's basketball players would not be permitted to travel because St. Lawrence was so isolated from other colleges. Additionally, many of the best institutions had done away with intercollegiate competition for women.

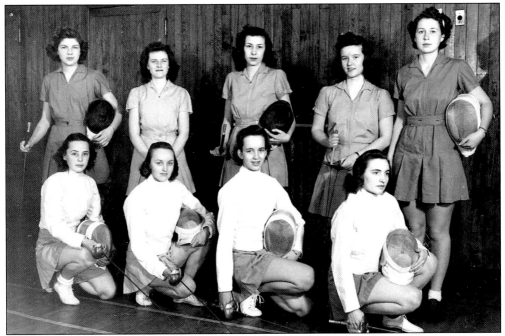

Shown here is the women's fencing team in 1941–1942. *The Scarlet and the Brown* describes fencing as an "intermittent" sport, but apparently it appealed to this group of women. Registrar J. Robert Williams, who wrote the chapter on athletics in the centennial history *Candle in the Wilderness*, could include only one short paragraph about women's sports. Current intercollegiate sports for women include basketball, cross-country, ice hockey, lacrosse, riding, alpine and Nordic skiing, softball, swimming, tennis, track and field, volleyball, crew, and field hockey.

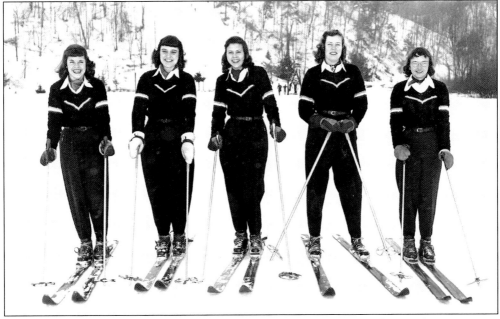

The St. Lawrence women's ski team competed at the Snow Bowl during the 1950s.

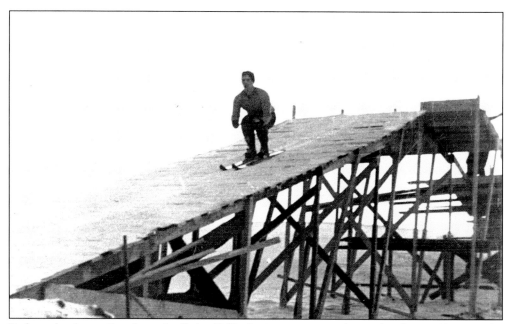

Before the Snow Bowl was built in 1940, St. Lawrence students skied at Bullis Woods, part of the Henry Bullis farm, now the site of State University of New York at Canton. When snow was lacking, as seems the case here, jumpers practiced on pine needles.

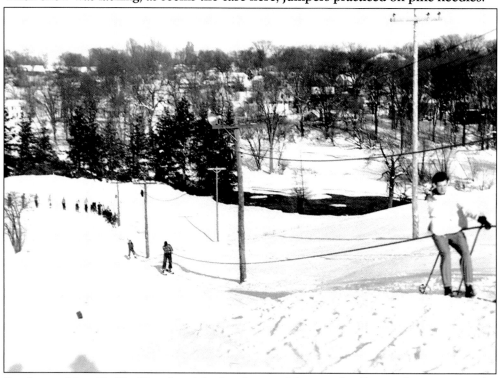

Students ski at Bullis Woods with the Grasse River and village of Canton in the background. This is probably just before 1940, when the Snow Bowl in South Colton began operations.

Students eagerly awaited the first snowfall and the opening of the Snow Bowl. Because skiing was relatively new to America and because the Snow Bowl was a premier facility, the sport was a novel and exciting winter adventure for students of the 1940s, 1950s, and 1960s. This is probably an Outing Club dry land clinic.

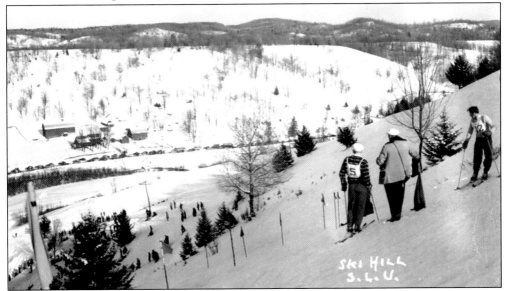

In the 1940s and 1950s, the Snow Bowl was one of the finest eastern ski hills and the home of the St. Lawrence Winter Carnival ski meet. The bulky man in the middle is likely James W. "Doc" Littlejohn, early ski coach and athletic trainer. Littlejohn mended athletes with lots of stories, lots of tape, "atomic balm," and a single whirlpool. The Snow Bowl's first rope tow gave way to a T-bar, and Littlejohn gave way to Otto Schneibs, who proclaimed, "Skiing is not a sport; it's a way of life."

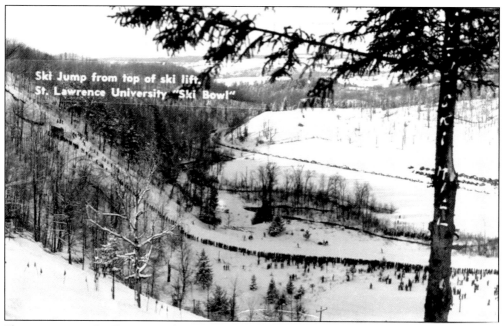

Ski jumping at the Snow Bowl was an exciting spectator sport. The 1956 U.S. Olympic team jumped at the Snow Bowl, and at that time, Art Devlin of Lake Placid set the hill record of 185 feet.

This flight at the Snow Bowl was a practice leap; if it were an intercollegiate meet, Route 56 would be lined with cars and spectators would crowd the outrun. For non-jumpers, merely standing at the top of the 60-meter jump could be terrifying.

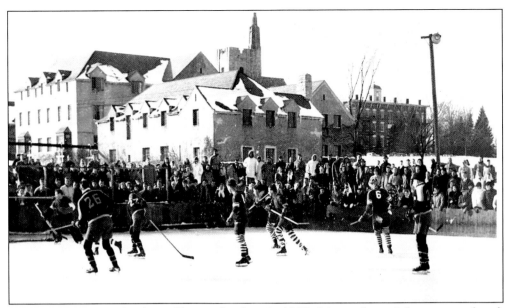

The North Country lends itself to ice hockey. In 1925, this outdoor rink was completed, and in 1926, intercollegiate play began—against Clarkson, of course. The current Whitman Hall is on the site of the old rink.

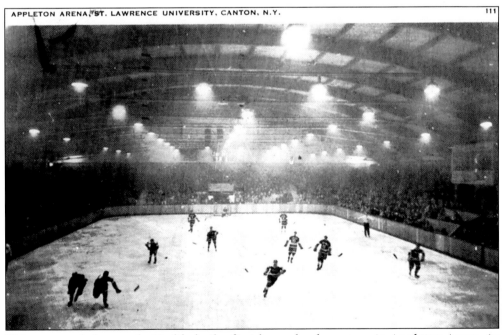

This postcard shows what is likely the first home hockey game in Appleton Arena, in January 1951. Dartmouth won 5-3, spoiling a 17-game St. Lawrence winning streak. In February 1955, when St. Lawrence beat Clarkson 2-1 in overtime, almost 5,000 people were packed into Appleton Arena (capacity 3,000). Before smoking was prohibited in the arena, by the third period of big games a dense pall of smoke hung over the ice.

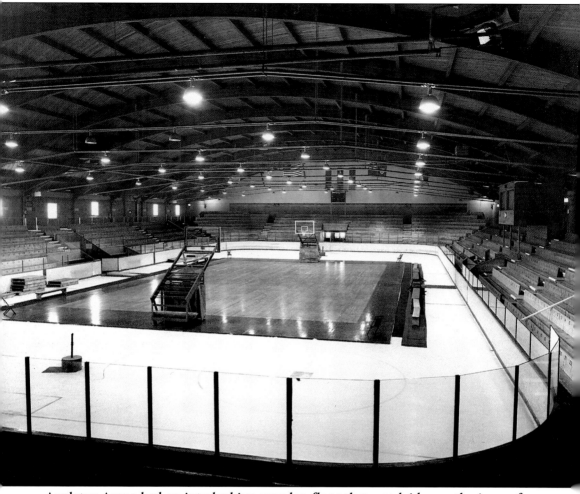

Appleton Arena had an interlocking wooden floor that was laid over the ice surface for basketball. The 1950 basketball team beat the Syracuse Nationals, a pre–National Basketball Association professional team, 69-67 in an exhibition game.

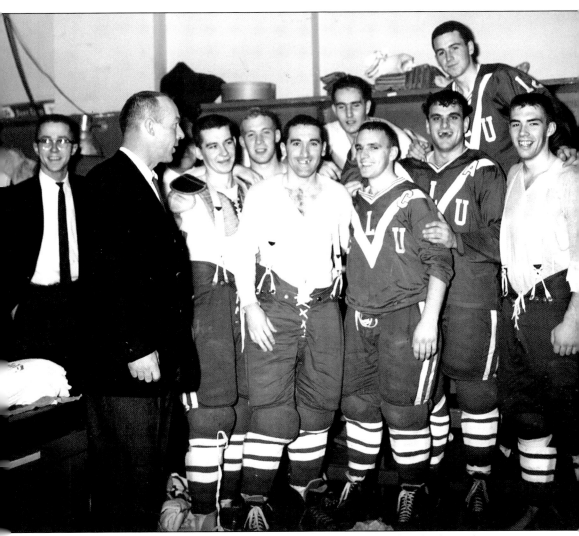

So what if a few teeth were lost? We won! This hockey team finished number one in the East in 1962. Coach George Menard is in the foreground. All-America Arlie Parker '61 is third from the right; in the center background is Ron Mason '64, who became the winningest college hockey coach of all time at Michigan State University. The 1988 men's hockey team and the 2003 women's hockey team competed for the NCAA Division I national championship.

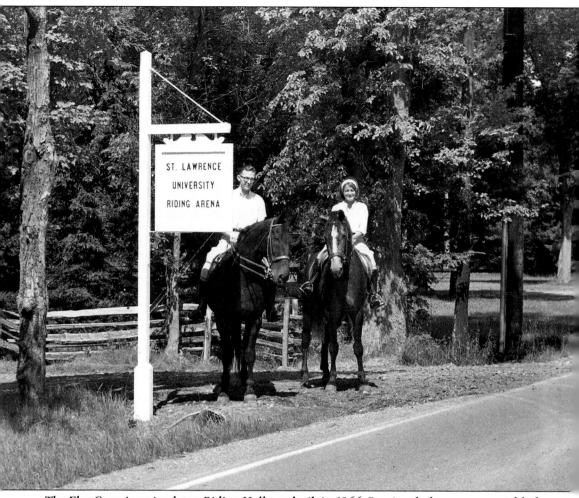

The Elsa Gunnison Appleton Riding Hall was built in 1966. Previously, horses were stabled at the red barn on the Russell Road, just beyond the bridge over the Little River. St. Lawrence riders have won the Cartier Cup, the national championship trophy, several times.

Wrestling was a successful and popular sport in the 1930s, led by colorful characters such as Duke Benz; Hayward "Pinky" Plumadore, who barnstormed as "the Masked Marvel;" and Isadore Demsky, better known as movie star Kirk Douglas. Coach John Clark '69 led a resurgence of wrestling in the 1970s, when large crowds cheered national champions Mitch Brown and Ron Pelligra.

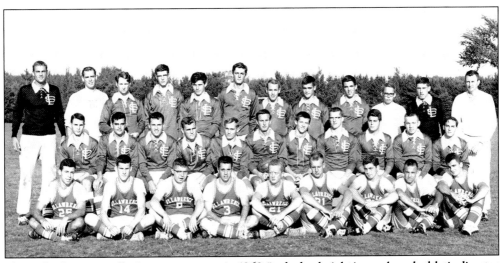

This is the first intercollegiate soccer team, in 1962. In the back right is coach and athletic director Thom Cartmill; on his right is goalkeeper Dan Sullivan '65, now St. Lawrence's president. In 1999, the men's soccer team won the NCAA Division III national championship.

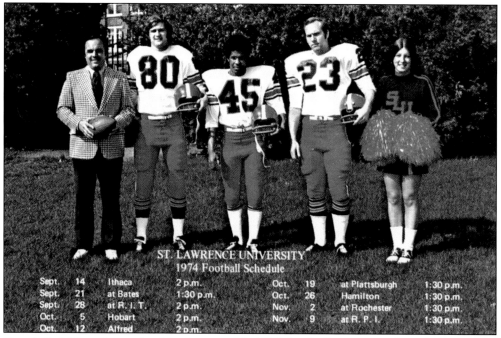

Coach Ted "Bear" Stratford is shown with 1974 football captains, from left to right, Steve Sutton, Donald Watkins, and Andy Reinhardt, with Pat Spring, a well-named cheerleader. Watkins, a diminutive but fast and fearless kick returner, was known as "Mighty Mouse."

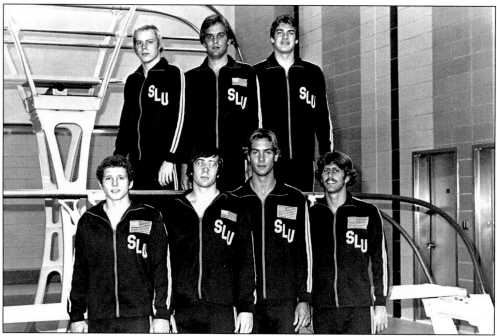

Pictured here is the 1976 NCAA Division III national champion men's swim team. Captain Jim Brush (front left) is now a university trustee, as were his father, John D. "Jack" Brush Jr. '50, uncle Richard "Dick" Brush '52, and grandfather John D. Brush Sr. '22.

# *Five*

# GREEKS

Beta Theta Pi (1879) was the first Greek social organization on campus. Initially, the fraternity brothers met in College Hall and called themselves the Five Lyres; later, they called themselves the P. D. (Plunder and Depository) Society. This was the first Beta house, on College Street. To keep expenses down, the Betas milked their own cow.

This is the mysterious interior of the Beta Temple. This temple was dedicated to the memory of Worth Abbott '00, Hugh Abbott '03, and John Young, second son of Owen D. Young and Josephine Edmunds Young. The provisions of the deed call for the temple to be open to the public every Moving-Up Day.

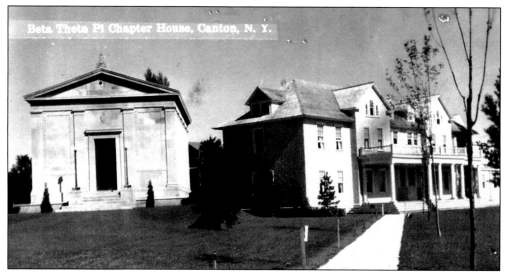

This early postcard depicts the Beta Theta Pi fraternity house (moved to this location in 1925) and the Abbott-Young Memorial Temple. Betas hold chapter meetings in the temple, which is connected by an underground passageway to the chapter house. It is one of only two Beta temples, the other being at Kenyon College in Ohio.

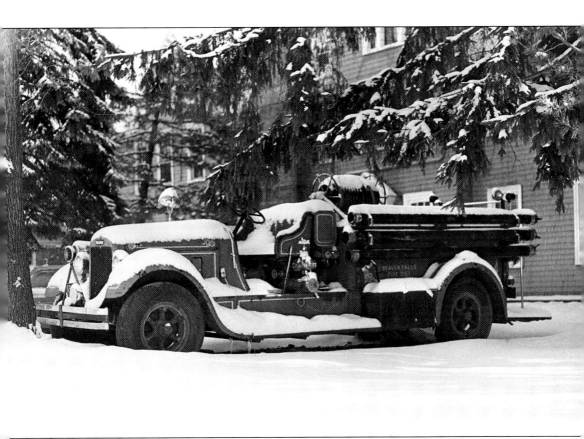

During the 1960s, 1970s, and 1980s, the Beta fire truck (a discard from a local fire company) carried Betas and guests to parties and football games.

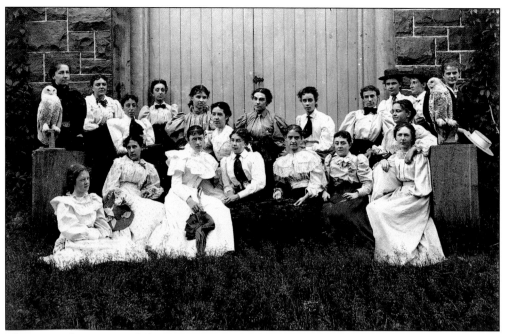

These are the sisters of the Kappa Kappa Gamma sorority in 1895. Seated in the first row, second from the left, is Elinor White. When she left to attend St. Lawrence, her boyfriend, poet Robert Frost, was plunged into the depths of despair. When her letters home revealed that she loved campus life, Frost, fearing he would lose her, pressured her to finish college in three years and marry him.

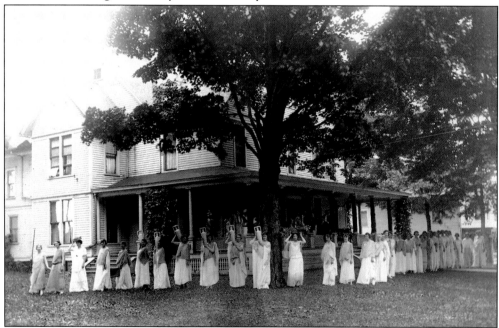

This is a commencement play at the Kappa Lodge in 1919. Surprisingly, this wooden structure on Main Street is the same building as the elegant Kappa Lodge of today. It received a major renovation when the brick façade was added in 1940.

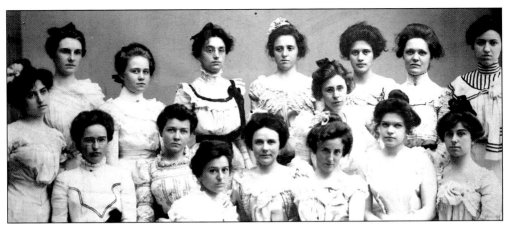

Delta Delta Deltas pose for the photographer around 1904.

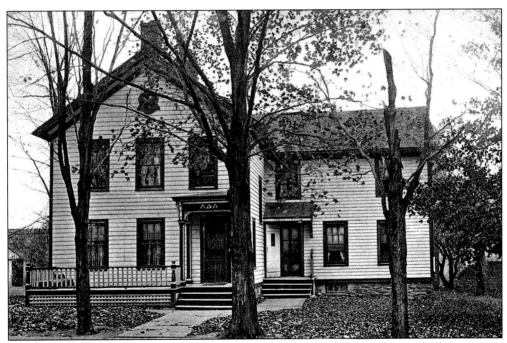

This early Delta Delta Delta sorority house was on College Street. In 1914, the Deltas purchased their present residence, on Judson Street.

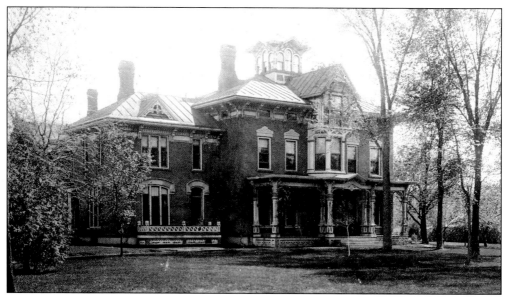

The residence of Judge Leslie Russell became the Alpha Tau Omega fraternity house in 1908. A later west wing addition included the Alpha Ballroom. The Alpha Ball, begun in 1889, and the Beta Ball, from 1875, were the gala social events of the college year. Each fraternity tried to outdo the other, with elaborate decorations and the best orchestras.

On the left in this picture of the porch of the Alpha Tau Omega house is Alexander "Sandy" Calder '09. The star on his L Club sweater designates him as a Star Athlete, a participant in four sports. Calder was a university trustee and chairman of the Union Bag and Paper Corporation. Arthur Laidlaw '11 (right) was a perennial returnee on alumni weekends and led his fellow Laurentians in spirited renditions of St. Lawrence songs.

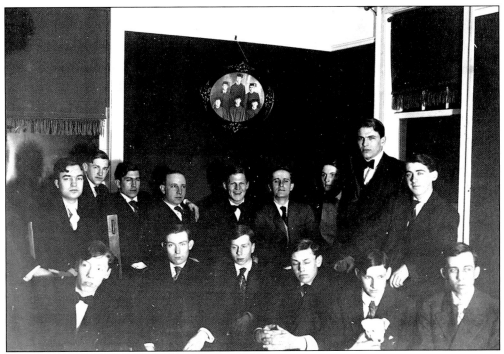

Alpha Tau Omega brothers pose for the cameraman in 1907.

Alpha Tau Omega brothers relax in the house basement. Fraternity basements were used for pool, table tennis, weight lifting, parties, and occasionally for study retreats.

Note the Gibson girl hairstyles in this Pi Beta Phi composite from 1916.

This is what a room in the Delta Delta Delta sorority house looked like in the early 1900s.

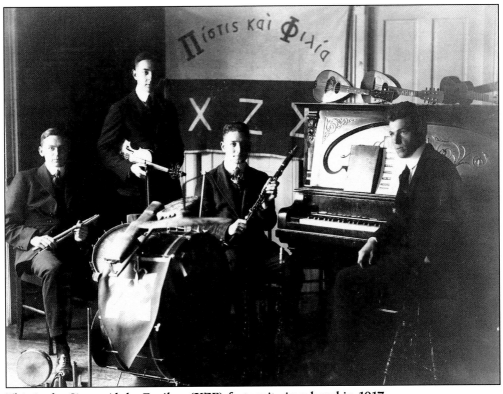

This is the Sigma Alpha Epsilon (XZE) fraternity jazz band in 1917.

Sigma Alpha Epsilon was "on tap" in these 1948 photos, taken in the house basement. Until the drinking age in New York was changed from 18 to 21, fraternity basements were popular campus watering holes.

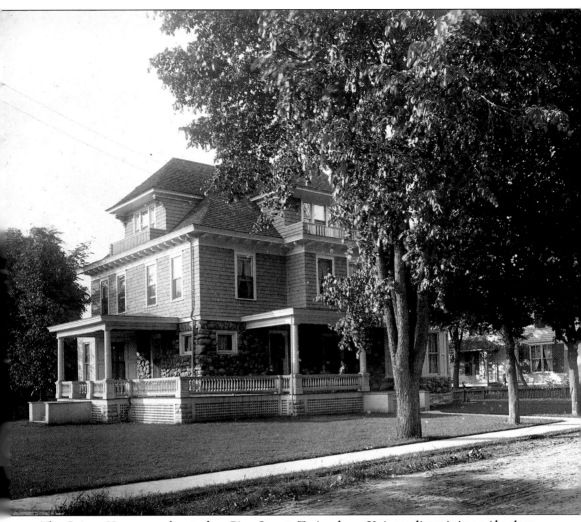

The Gaines House was located on Pine Street. Trained as a Universalist minister, Absalom Gaines was president from 1873 to 1888. It is said of him, "He did justly and loved mercy and walked humbly before his God." Gaines House became a residence for independent women and then the first home of Chi Omega sorority.

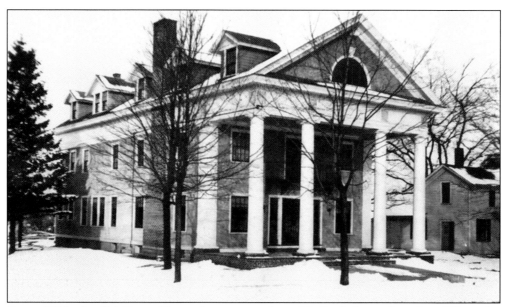

From 1906, the Phi Sigma Kappa house stood on this Park Street location. When the fraternity was disbanded in 2004, the building reverted to its original name, Gilson Hall, in honor of Lt. J. Proctor Gilson, a Phi Sigma Kappa alumnus killed in France during World War I. The building now houses Commons College.

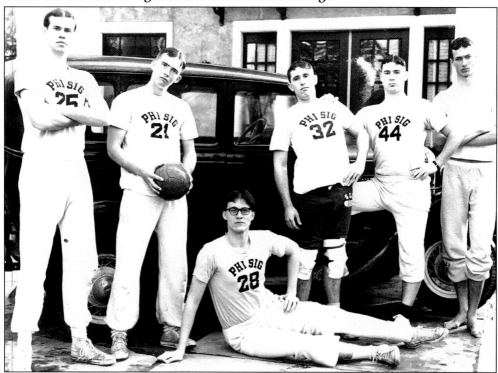

Don't be deceived by the vintage car and the retro poses. This is the 1964–1965 Phi Sigma Kappa intramural basketball team, winner of the national Phi Sigma Kappa intramural competition. Number 32 is Dan Sullivan '65, current president of St. Lawrence University.

In the late 1940s, alumni, students, and friends raised $400,000 for Appleton Arena, an indoor skating rink. Pictured is the Alpha Delta Pi sorority's display to help the campaign. Appleton Arena is named for Judge Charles Appleton 1897, a trustee of the college from 1910 to 1941 and former general counsel to the General Electric Company.

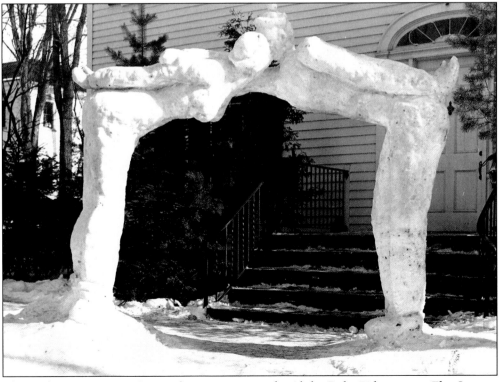

This is the 1952 Winter Carnival snow statue at the Alpha Delta Pi house, on Elm Street.

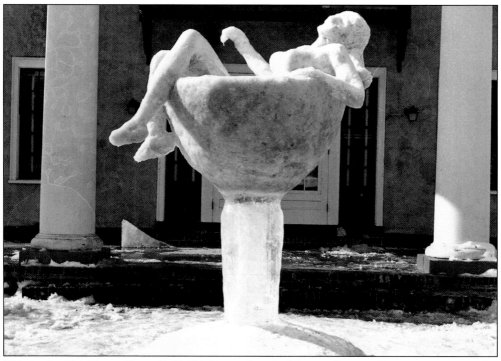

This is the Phi Sigma Kappa's 1952 Winter Carnival ice sculpture. For many men in the 1950s, this picture is a reflection of their fantasies about women and alcohol.

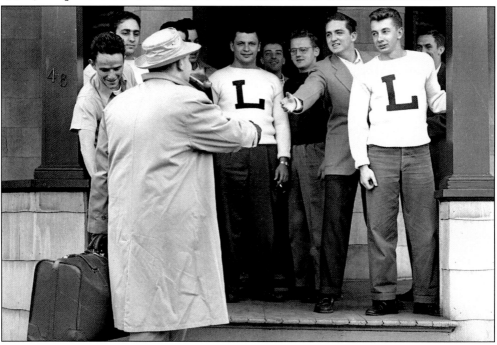

Sigma Pi brothers greet what could be a pledge or a visiting alumnus. Rushing of first-year students began even before the college was in session. Pledges were recruited during their first trip north on the train called the "Canton Creeper."

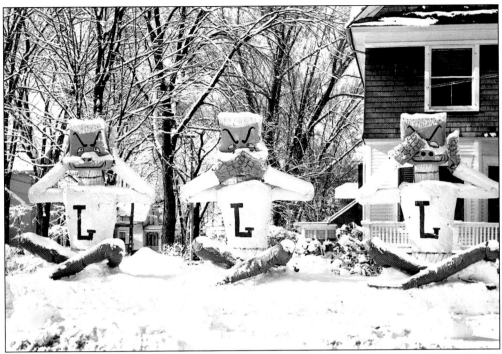

"See No Evil, Speak No Evil, and Hear No Evil" is Sigma Chi's interpretation of "Larryland." This snow sculpture won first place in the 1954 Winter Carnival competition.

Sigma Chi Derby Day was a yearly event in which teams of women competed for recognition from the fraternity. This photograph from 1970 shows typical hijinks on the quad. Covered with shaving cream is Shelley Thompson '72.

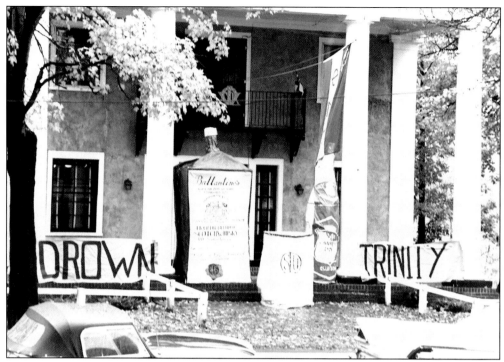

Pictured here is Phi Sigma Kappa's display, probably for Homecoming Weekend. Judging from the cars and the fact that Trinity College was the football opponent, this photograph was taken about 1960.

Can it be snowing at this 1966 spring Pledge Saturday at Phi Sigma Kappa fraternity? The Interfraternity Council issued bids to men who had rushed a fraternity. When the bids were accepted, the fraternity brothers greeted the new men with a pledge pin to certify their affiliation. A period of pledge training was followed by Hell Week.

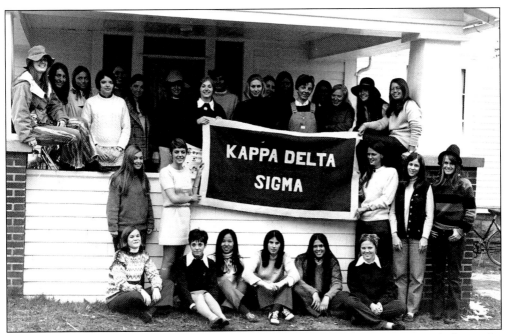

When informed by their national sorority Kappa Delta that they could not pledge Lydia Minatoya '72 because of her ethnic background, these women rebelled. With the full support of the university administration, they withdrew from Kappa Delta and emerged as local sorority Kappa Delta Sigma. When they were banished from their Park Street house by the national sorority, the university bought the house and reinstalled the local sorority. Lydia Minatoya became a writer and college professor.

In 1950, the women of Pi Beta Phi moved from their Park Street house to their new house on Romoda Drive at the edge of the campus. Penny loafers and bobby socks were the approved footwear.

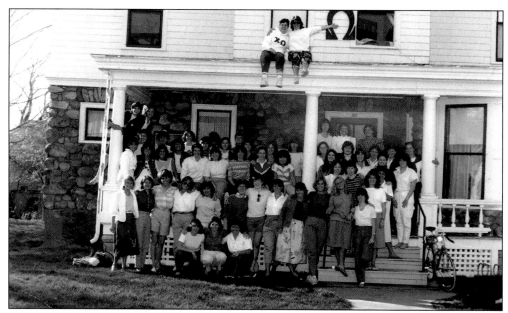

The Chi Omegas turn out on the porch of their house, at 20 Pine Street. Chi Omega sorority was chartered at St. Lawrence in 1981. It was the last Greek organization formed on campus.

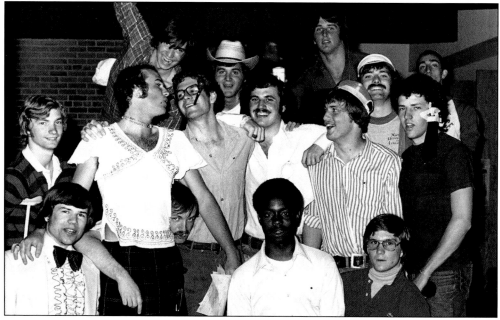

This zany group is the Phi Kappa Sigma pledge class of 1976. In their first year on campus, the Phi Kaps lived in World War II surplus housing in Vetsville. They now live in what was previously called Lee House, located at 1 Lincoln Street. Legend holds that Lee House is inhabited by a ghost, Florence Lee Whitman, daughter of the university's first president. While the legend says that she died tragically at a young age and roams the halls in a red petticoat, closing doors and shutting off rock music, in fact she lived a long and productive life and became a university trustee.

# *Six*

# OTHER CAMPUS ORGANIZATIONS

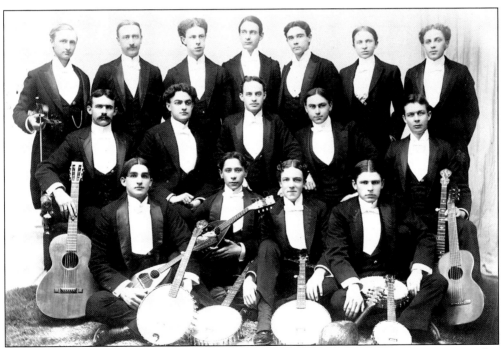

Pictured here is the Banjo Club of 1896. Edson Miles '00 (back center) became a Universalist minister and Shakespearean actor and was named by St. Lawrence as the Ryder Professor of Homiletics and Pastoral Theology. For 24 years he directed the Mummers, the drama club. *Candle in the Wilderness* reports that Miles's players "made a name for themselves far and wide in eastern collegiate circles." Most students today call the Edson R. Miles Theater in Griffiths Art Center "the Black Box."

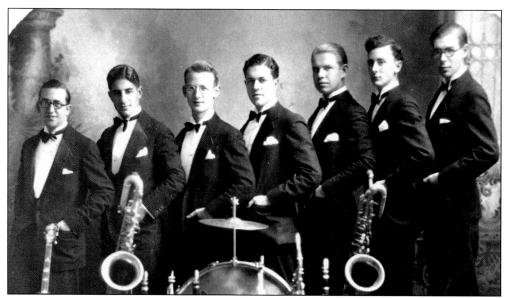

The Blue Stompers jazz band strikes a dignified pose. Music played a big part in student life in the Roaring Twenties. J. Kimball Gannon '24 wrote "Alma Mater" and had 200 songs published, including Glenn Miller's "Moonlight Cocktail," "I'll Be Home For Christmas," "A Dreamer's Holiday," and "Autumn Nocturne."

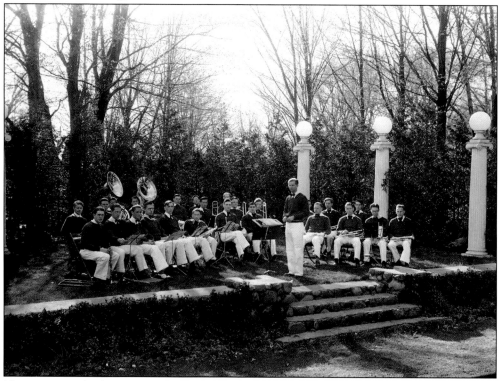

These serious-looking young men are members of the 1932–1933 St. Lawrence University Band. They are seen performing at the Gaines Open Air Greek Theater on Charter Day in 1931.

Pictured in the chapel is the Men's Glee Club of 1930–1931. Myles Rodehaver (second row, third from the left) was for many years head of the Sociology Department at his alma mater. Before the 1970s, department heads, like judges, were appointed for life; departments were a reflection of their leadership.

These 1927–1928 aspiring writers are the staff of the *Scarlet Saint*, the first major student literary publication. The *Laurentian*, which appeared a few years later, continues to be published. These were the most successful of the student literary efforts. The *Moose News*, *Incubus*, *Forum*, the *Stump*, and *Northern Light* were of shorter duration.

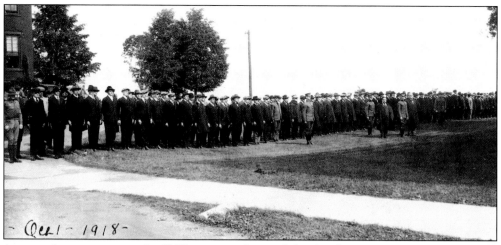

At attention on campus in 1918 are members of the Students Army Training Corps. The organization was the predecessor to the Reserve Officers Training Corps (ROTC). Following World War II, St. Lawrence had a Military Studies Department and regular drill on Friday afternoons. Most men joined ROTC; today, students wanting to join affiliate with Clarkson's program.

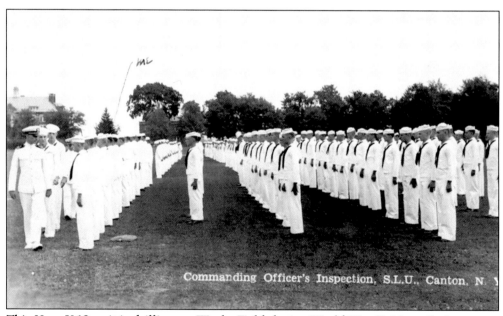

Commanding Officer's Inspection, S.L.U., Canton, N. Y

This Navy V-12 unit is drilling on Weeks Field during World War II. Many St. Lawrence students and faculty enlisted during the war, and enrollment declined severely. It is said of the V-12 unit that "it kept the college afloat."

In the back right of this picture of the Debate Team is Joseph J. Romoda '33. The entrance to the campus is named for Romoda, dean of the college from 1949 to 1966.

Chief Ernest M. "Ernie" Benedict of the Akwesasne (St. Regis) Mohawks was a 1940 graduate of St. Lawrence. In the 1960s, students, led by government Prof. Robert Wells and Mohawk leader Minerva White, launched Operation Kanyengehaga. Some 50 St. Lawrence students traveled two or three nights a week to the Mohawk reservation to tutor children of elementary to high school age. St. Lawrence shares a long history with the Akwesasne Mohawks; several tribal leaders have been St. Lawrence graduates.

This happy vocal group is the original singing Saints, pictured in Gunnison Memorial Chapel in 1952. In June 2005, several of the original singers returned to the chapel during Reunion Weekend and performed in a concert with Saints from the past 50 years. The Sinners, the all-women's a cappella group, were formed a few years after the Saints.

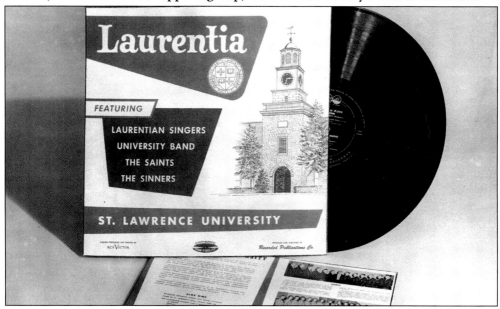

*Laurentia*, a 1960 recording, features performances by various St. Lawrence University music groups. The Laurentian Singers always sang "A Tribute"—"Nestling 'neath the purple shadows of the Adirondack hills, lies our noble Alma Mater, thoughts of whom our memory fills." The Saints' favorites were songs such as "Teasin'" and "Over the Rainbow," and the Sinners liked "A Good Man is Hard to Find" and "Basin Street Blues."

The Outing Club was founded in 1937. It is the second oldest in the country, the club at Dartmouth being the first. From the 1940s to the 1960s, a small fee at registration and some mild coercion from upper-class students guaranteed that 80 percent of the student body belonged to the club. The Outing Club house, one of the original theme cottages, has been the headquarters since about 1980. Club president John Marino '83 initiated Peak Weekend, placing St. Lawrence students on all 46 Adirondack High Peaks on the same day.

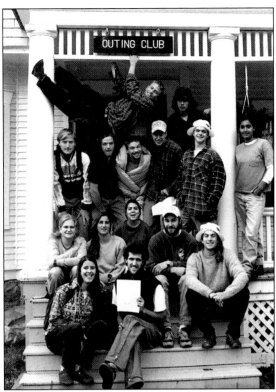

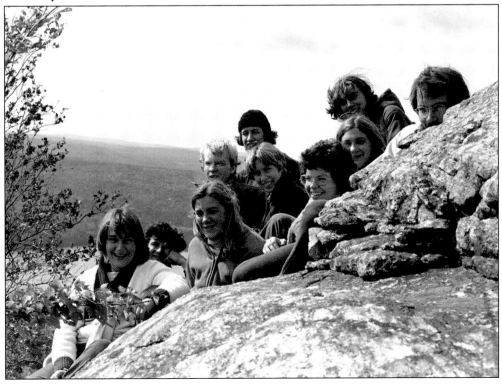

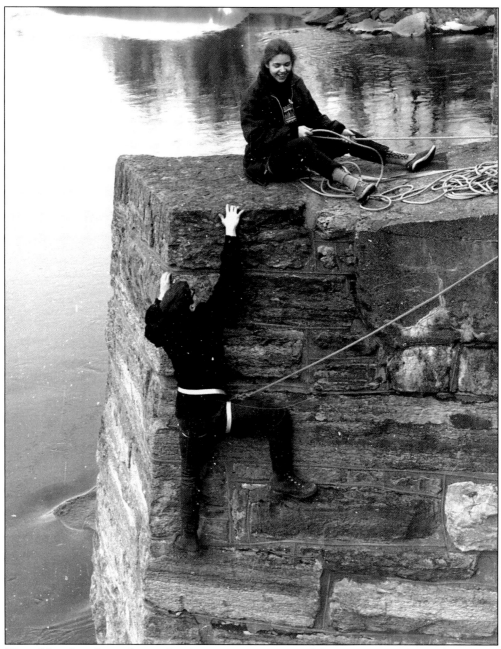

This old railroad trestle on the Grasse River was used for practice rock climbing. The Outing Club has encouraged hundreds of students to take advantage of the university's location by participating in skiing, climbing, hiking, paddling, and camping in the nearby Adirondacks. A full-fledged Outdoor Program was begun in the 1990s. Rock climbers can practice on the Munro Family Climbing Wall in Newell Field House.

The L Club, the letterman's organization, was responsible for orienting (hazing) freshman men. L Club men wore their letter sweaters to class every Friday. Jim Hefti (with the collar, back row, middle) appears in this 1941 L Club photograph. He went on to play fullback for the professional Washington Redskins.

The 1947–1948 Larryettes were women who did not affiliate with a sorority. During the 1940s, 1950s, and 1960s, most St. Lawrence men and women joined a fraternity or sorority. In the 1950s and 1960s, there was also a Larriettes women's skating club that performed synchronized routines between the periods of hockey games.

This is the KSLU radio station, located in the basement of Gunnison Memorial Chapel. Operated by students, the station had a range that included the campus and parts of Canton village. It provided a mix of music, news, and sports, including broadcasts of the hockey games. WSLU, begun on campus in 1968 as an FM station with limited range, has evolved into North Country Public Radio, a National Public Radio station now heard from Ottawa, Canada, to Burlington, Vermont, and throughout the Adirondacks.

Bruce Kashdan '66, the founder of the Community Development Corps, stands by the organization's bulletin board. The group's goal was to improve rural living conditions in the region. Students visited the elderly, conducted food and clothing drives, repaired rural homes and playgrounds, and tutored adults preparing to take high school equivalency tests.

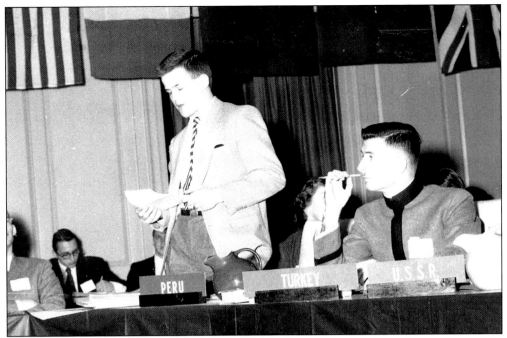

The Model United Nations Security Council began in 1949. Students from eastern U.S. colleges and Canada met in the Commons Room in Men's Residence to debate various world issues. The parliamentarian in the photo below is Prof. Carl Chilson of the History and Government Department. Henry "Harry" Reiff, St. Lawrence faculty member from 1928 to 1966 and long-time head of History and Government, was adviser to the Model United Nations. Reiff's Thursday morning government quizzes were notorious; for his students, Wednesday night was "give your life to Reiff."

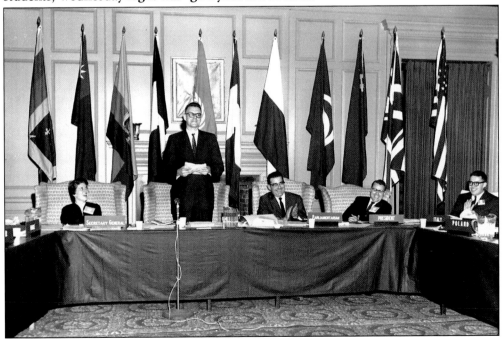

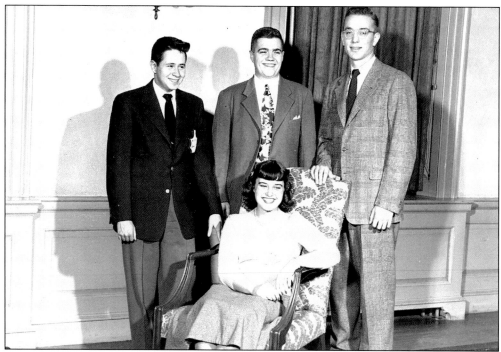

The Thelomathesian Society, an elected student government organization, has been continuous since 1863. The name of this organization comes from the Greek for "love of knowledge." Pictured above are officers for 1949–1950. Bill Davis '50 (standing, left) was the university's alumni secretary for many years. Pictured below are the 1953–1954 officers. Brian McFarlane '55 (back right) was the longtime anchor for the Canadian Broadcasting Corporation's "Hockey Night in Canada."

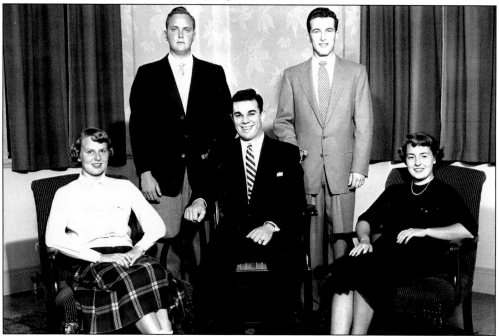

Reserve Officers Training Corps Cadet Comdr. James Kuhns '59 is congratulated by Lt. Col. Martin Waters. On Friday afternoons in the 1950s and 1960s, Weeks Field was filled with marching, drilling cadets. During those years, ROTC enrolled the majority of men students, but it fell out of favor during the Vietnam War years.

These are members of the Black Student Union group around 1970. In 1966, a total of 10 African American students entered with the freshman class. Before that, there had been only three African American students in the college's history. Jeffrey Campbell '33 is thought to be the first African American student at St. Lawrence.

Director J. Richard "Papa G" Gilbert and the Laurentian Singers traveled widely. Gilbert conducted the Laurentian Singers at guest appearances in Carnegie Hall, the White House, and Canada's parliament, where they were the first singing group to perform.

*Seven*

# THE VILLAGE OF CANTON

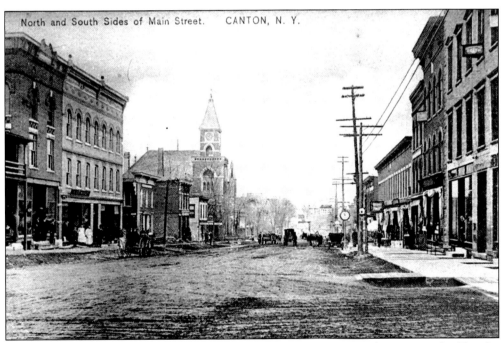

This 1908 postcard shows Canton's unpaved Main Street. An early car is parked by the clock. A wooden covered bridge spans the Grasse River at the foot of Main Street.

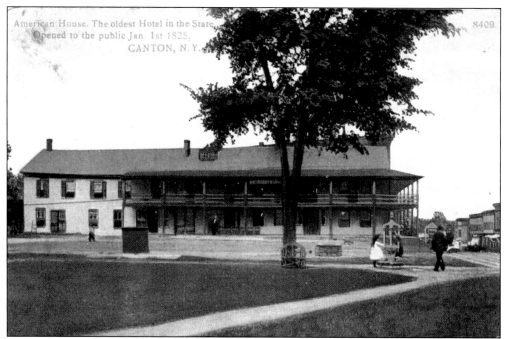

Canton's claim that the American House, shown in this 1909 postcard, was "the oldest hotel in the state" is spurious. The post office is on the site of the American House.

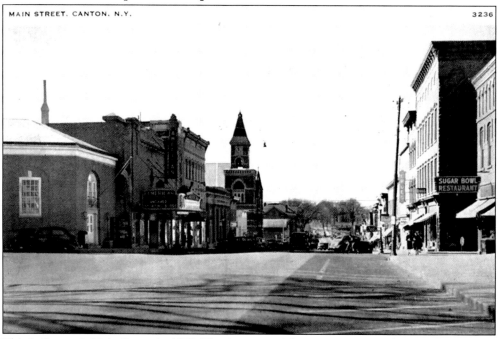

This is Canton's Main Street in 1953. The American Theater marquee advertised *Untamed* and *Sporting Blood*. The Sugar Bowl was a popular hangout. On Friday nights, fraternities and sororities did not serve dinners; many students ate at the Sugar Bowl or at McCarthy's, on Route 11, where a chicken-and-biscuit dinner and a dessert of cake and ice cream cost $1.

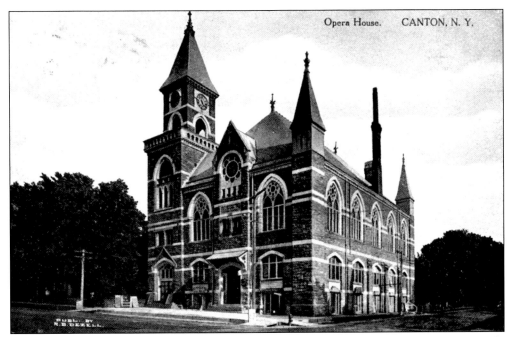

The Opera House, which became the Canton Town Hall, was built in 1877. In its early years it was the site of university commencement exercises, as well as local and college dramatic productions, visiting acting troupes, and minstrel shows. In 1886, an emergency meeting to consider closing the college was held in the town hall. One by one, students came forward and pledged over $1,000 from their meager savings. Their spirit inspired the citizens of Canton, who raised $17,400. The college was saved. The town hall burned in 1962.

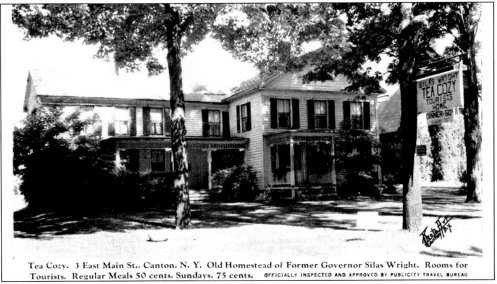

Tea Cozy. 3 East Main St., Canton, N. Y. Old Homestead of Former Governor Silas Wright. Rooms for Tourists. Regular Meals 50 cents. Sundays, 75 cents.    OFFICIALLY INSPECTED AND APPROVED BY PUBLICITY TRAVEL BUREAU

No. 3 East Main Street was the home of Silas Wright, a U.S. senator and the governor of New York from 1844 to 1846. It became the Tea Cozy, a tourist home with dinners for 50¢. Later, it was the Universalist parsonage. Now, it is home to the St. Lawrence County Historical Association.

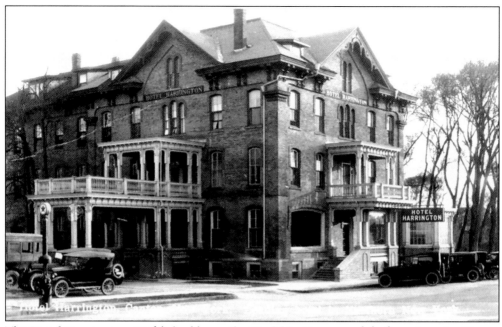

The Hotel Harrington (1864) had been the Hodskin House and, before that, the Haven House. Not surprisingly, St. Lawrence students called it "the H." The hotel's basement bar was a popular hangout. Unfortunately, the hotel was replaced by a gas station in 1958.

The counterpart to "the H" was "the R." Originally known as the Erwin House, the building became the Hotel R, named for the owners, Mr. and Mrs. Louis J. Russett. It burned to the ground in the winter of 1949–1950, and was rebuilt as the St. Lawrence Inn. Whatever the name, generations of St. Lawrence students called it the R. It was razed in 2004–2005.

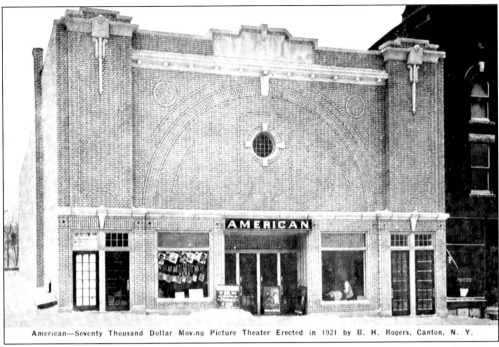

American—Seventy Thousand Dollar Moving Picture Theater Erected in 1921 by B. H. Rogers, Canton, N. Y.

In its day (1921), the American Theater was a grand venue for movies, plays, and visiting performers. Today, it has been divided into five small movie theaters.

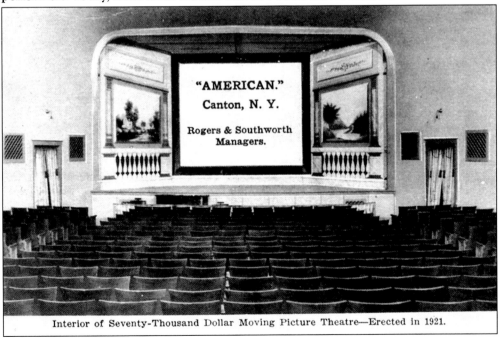

Interior of Seventy-Thousand Dollar Moving Picture Theatre—Erected in 1921.

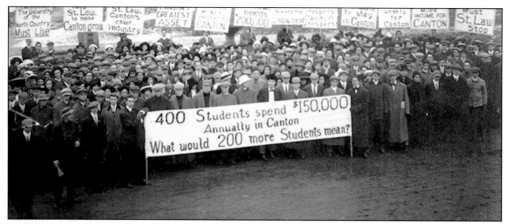

The early college endured trying years. In 1900, the graduating class numbered only 17, and the endowment was $234,725. Although an 1880s effort had raised $50,000, the Million-Dollar Fund Drive was the college's first major fund-raising effort. From the looks of this rally, the students were not bashful in seeking financial support from Canton's citizenry.

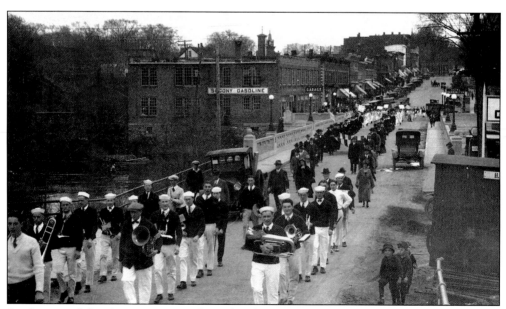

Students and faculty join in marching for the Million-Dollar Fund Drive in 1923. The early college was very much a part of the Canton community.

126

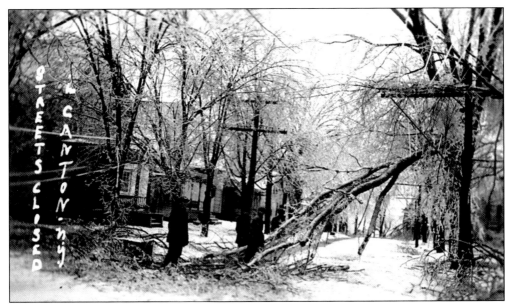

As these old postcards show, the famous 1998 ice storm was not the first. In 1998, many Canton area homes were without power for as long as three weeks; perhaps Cantonites were able to recover faster in the old days when they were less reliant on technology.

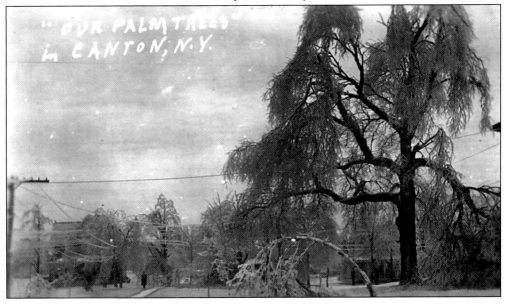

Artist Tom Glover '52 draws another caricature at the Tick Tock restaurant, owned by Anthony "Tony Tick Tock" Scalise '43 (back right). There were several downtown hangouts for students, but the Tick Tock was the most popular.

The drummer is Tom Matthews '53. Glover's drawings lined the walls of the Tick Tock restaurant and bar.